Praise for Alice Sink's writing

"Alice Sink entered a short st ·iting content. She got a call from · ; and experience, they asked her to be a co-editor of an anthology *Paradise*." Soyia Ellison, Lexington *Dispatch*.

"Sink has taken her memories and channeled them into five years of research and writing that resulted in her latest book *The Grit Behind the Miracle*, which chronicles the true story of the Infantile Paralysis Hospital that was built in 54 hours in 1944." Jill Doss-Raines, Lexington *Dispatch*.

"Throughout the rare glimpses from 1900 to around the early 1950s, Sink stuck to one consistent theme in *Kernersville*. Sink portrayed…the sense of community." Brandon Keel, *Kernersville News*.

"*Boarding House Reach* reminds us of one of the most important truths of life: There are no ordinary people! Every story here is fascinating—and every one importantly belongs to history." Fred Chappell.

"*Boarding House Reach* [is] North Carolina history, the likes of which has not been done before…fascinating and fun to read." Ruth Moose.

"[*Boarding House Reach* is] a fascinating survey of the history of North Carolina boarding houses and the women who ran them." Professor Frederick C. Schneid, High Point University.

"[*Boarding House Reach* is a] delightfully engaging and well-researched book." Professor Ed Piacentino, High Point University.

"Community abounds in a colorful new book about the history of North Carolina boarding houses—a traveler's guide to a lost place that was small-town and worldly at the same time." Lorraine Ahearn, Greensboro *News & Record*.

"Accompanied by numerous period photographs, *Boarding House Reach* is filled with recipes for Southern classics like grits, country ham, cheese rings, corn bread, and coconut pie, many of which come directly from the original boarding houses' cache of recipes." Angela Leeper, *Our State* magazine.

"While most of the stories have a common thread of financial need because of being widowed, having a sick spouse or just needing extra money, each story [in *Boarding House Reach*] dives deep into the female proprietor's life and educates readers about famous guests or the happenings in each town." Jill Doss-Raines, Lexington *Dispatch*.

"A very highly recommended addition for academic and community library collections, *Boarding House Reach* could serve as a template for similar studies for other states." *Midwest Book Review*.

HIDDEN
HISTORY
of the
PIEDMONT
TRIAD

ALICE E. SINK

Charleston · London

THE
History
PRESS

Published by The History Press
Charleston, SC 29403
www.historypress.net

Copyright © 2009 by Alice E. Sink
All rights reserved

Images are courtesy of the author unless otherwise noted.
Cover design by Marshall Hudson

First published 2009

Manufactured in the United States

ISBN 978.1.59629.685.5

Library of Congress Cataloging-in-Publication Data

Sink, Alice E.
Hidden history of the Piedmont triad / Alice E. Sink.
p. cm.
Includes bibliographical references.
ISBN 978-1-59629-685-5
1. Greensboro Region (N.C.)--History--Anecdotes. 2. Winston-Salem Region (N.C.)--
History--Anecdotes. 3. High Point Region (N.C.)--History--Anecdotes. 4. North Carolina--
History, Local--Anecdotes. 5. Piedmont (U.S. : Region)--History, Local--Anecdotes. I. Title.
F264.G8S56 2009
975.6'5--dc22
2009019602

To our grandchildren—Cole, Jackson, Isabelle, Philip and Cortney—I dedicate this book. To them I am not a university professor or published author. I am simply Granny the Great, who puts on her majorette suit and white leather boots and marches with them around the yard—the boombox blaring Souza—or makes special costumes and encourages them to perform original plays on the stage built in our basement! I love you, kids.

CONTENTS

CONTENTS

CONTENTS

PREFACE

The Piedmont Triad of North Carolina has three major cities—Greensboro, Winston-Salem and High Point. Secondary cities over ten thousand in population include Asheboro, Burlington, Clemmons, Eden, Graham, Kernersville, Lexington, Reidsville and Thomasville. Fifty-three other municipalities under ten thousand in population call the Piedmont Triad home. I wish I could have included all of them, but…maybe in volume two of *Hidden History*.

As a lifelong resident of this area and a writer, I am extremely interested in Piedmont Triad history. I especially like those out-of-the-ordinary historical truths that, for some reason, rarely appear in books. When in college, I always gravitated to the true stories of the king who slept in a coffin or the ruler who refused to cut his toenails—true hidden histories. Battles, famous people, events and facts and figures did not interest me—unless I found something unique or even quirky.

Some of the material included in this book has been stored in my file cabinet for years and years. I suppose it has been waiting for the right time for sharing. To my knowledge, everything I have written is true and documented. Specifics, illustrations and examples come from various sources, which my bibliography will reveal.

I had a great time writing this book, and I hope you have as much fun reading it. I have met many unique people and experienced the ultimate joy of getting in touch with the hidden history of my native Piedmont Triad area.

Acknowledgements
and Contributors

Special thanks go to my husband, Tom, who has given me many great suggestions for this book—especially his memories of Ivey Briggs's Service Station and Garage—and who, furthermore, is the best proofreader, speller and photographer around. Also, I could not have completed this book without the wonderful help of Laura All, senior commissioning editor/publisher at The History Press. She answered all my questions and guided me back on the right path when I strayed. She gave me suggestions when I was at a total loss about what to do. To David Bryden, head librarian at High Point University, I say thanks for being such an expert on copyright laws and answering any and all questions I have about legality. Nita Williams at the HPU Smith Library also helped guide me to people and places I never dreamed existed. To Danielle Jackson, editor of *TriadLiving* magazine, and to Rob and Andrea Steiner, editors of *TriadWedding* magazine, I extend sincere appreciation for freelance assignments that have taken me over the entire Piedmont Triad. Martha and Larry Stafford, Buddy Brown, Fred Harb, Michelle Devlin, Reverend/Dr. Ellen Yarborough and Eileen Ayuso provided me valuable materials and assistance. I am especially grateful to fellow writer Trudy Jones Smith, who graciously allowed me to use her photograph of the Lawson family from her book, *White Christmas, Bloody Christmas*. Sincere appreciation goes to daughter Corey, who helped me through many computer glitches, and to daughter Lydia, who "drove Miss Alice" to and fro to places in Stokes County I would never have found in a hundred years.

PART I

PEOPLE

Captain Peter Summers

According to President George Washington's diaries, 1791–1799, Peter Summers, a hero of the American Revolution and member of the First North Carolina Battalion, accompanied General Washington and Governor Martin on June 2, 1791, to the grounds of the Battle of Guilford Courthouse.

George Washington's correspondence to Lieutenant Peter Summers dated July 9, 1781, indicates that Summers, at the age of twenty-four, requested permission for dismissal:

> *To Lieutenant Peter Summers:*
> *Head Quarters near Dobbs ferry, July 9, 1781.*
>
> *Sir:*
>
> *I have recd. yours of the 19th of June. Previous to the acceptation of your Resignation you must lodge Certificates from the pay Master General and Auditor of Accounts that you have no public money charged against you, and you must obtain an approbation of dismission [sic] from the Colonel or commanding Office of the Regt.*
>
> *To which you belong. I am &c.*

Captain Peter Summers reportedly built the first brick house in Guilford County and attended Frieden's Lutheran Church. In the American Revolutionary War, he served as a captain in the First North Carolina Battalion—the part of the American army that surrendered Charleston, South Carolina, on May 12, 1780.

How strange, though: in 1780, Summers is listed as a captain. In 1781, his rank is listed as lieutenant. In the U.S. Army, captain is a higher rank than lieutenant. A forgotten fact? Interesting!

Elreta Melton Alexander-Ralston

Elreta Alexander-Ralston became the nation's first black female district court judge on December 5, 1968. For Ms. Alexander-Ralston, being "first" came naturally. She received the honors of being the first black woman to be accepted to Columbia University School of Law, the first black woman to earn her degree from Columbia and the first black female lawyer in North Carolina's history.

Remembered for her fairness and compassion on the Guilford County bench, Judge Alexander-Ralston, or "Judge A.," pioneered two successful programs. She supported early first offender and community service programs, and she originated what she called "judgment day," when first offenders would return to her courtroom several weeks after their trials. If they had stayed out of trouble, she dismissed all charges.

Judge A. also exhibited extreme candor. The following true story illustrates her honesty:

> *One day a white woman whose daughter had run away appeared in her court. The mother approached the bench and whispered, "The worst thing is that the girl's running around with colored boys," to which Judge Alexander-Ralston responded, "Darling, have you looked at your judge?"*

In May 1978, Alexander-Ralston threatened to jail all of the Guilford County commissioners if they did not do something about overcrowding in the Guilford County jail. Fortunately, she did not have to carry out her edict.

When she retired from the bench in 1981, she resumed the practice of law in Greensboro as a senior partner in the firm Alston, Alexander, Pell & Pell. Elreta Narcissus Melton Alexander-Ralston died at the age of seventy-eight.

Rosa Thornton and Whiteford Smith

Since Mr. Smith was a member of Millers Methodist Episcopal Church South near Mullins, South Carolina, and not a Quaker, he could not marry

his beloved Rosa in her Deep River Friends Church in Guilford County. This, apparently, constituted only one unfortunate incident in his life.

After being refused in the Quaker church at Deep River, Rosa married Whiteford in the Methodist Episcopal Church South in High Point. Immediately after the service, the couple left for South Carolina.

According to genealogical records, Whiteford Smith held many different jobs at the beginning of the twentieth century. When he worked at the post office, he first rode an Indian Runner motorcycle to deliver the mail. He replaced this with a Harley-Davidson and a sidecar. Another job involved buying cotton bales. Then he got a job as a bank accountant and worked long hours, often sleeping in the bank directors' meeting room until, sometime during the night, his son would pick him up with their horse and buggy and take him home. When he lost his bank job during the Depression, he left his wife Rosa and their children—saying that he needed to find work in another state.

One story indicates that Whiteford went to Alabama but occasionally returned to his family. Another scenario involved Whiteford running away with a hairdresser named Irene, who later left him. He wanted Rosa to take him back, but two of Whiteford's brothers met him on his arrival back home and told him to leave and never come back. They cited Whiteford's former abuse of Rosa.

Years later, when Rosa and Whiteford's son Thornton was a seminary student at Duke University, he received a message that his father wanted to meet him at the Melbourne Hotel—just to talk and see him and his brother, Carlisle. They complied. Thornton did not see his dad again until 1950, when Whiteford asked for his help in entering a rest home. Whiteford Fleming Smith died on December 21, 1951.

While her husband was gallivanting about the countryside, Rosa recalled a portion of her life in correspondence with her children. In one letter to Thornton, she reminisced about her New Garden School education, her early days of teaching school at Deep River and her four-mile trek every morning and evening. Rosa apparently never faulted Whiteford for leaving, and she said she had a good life, after all:

> *I've about done some good and done some wrong. The Lord has blessed me with five good living children for which I am thankful. And all of their wives have been good to me. Carlisle has bought me old lady comfort shoes at price $4.00 and dress shoes at $10. Ain't the prices of everything awful now! Then the nice coat suit and white blouse. Just dresses me up perfectly. Thank you! Many, many thanks and all good wishes for your health and happiness. Love to all, Mother.*

People

Rosa's children noted that she continued to believe in the Quaker doctrine even though she became a Methodist, which was a Smith tradition. She made them memorize scripture passages instead of punishing them, and she constantly sang hymns. Rosa died in 1958.

Flyboy

Lindley Park Filling Station, a restaurant in Greensboro, recently hung up a portrait of Tom Warth, a local World War II fighter plane pilot who flew eighty-two missions to prevent German fighters from attacking American bombers flying to Germany, France and Russia.

Warth still has his flight records, which vivify the fear, anxiety and excitement of flying four hundred miles per hour at twenty-five thousand feet, navigating with a stick and continuously spotting enemy fighters around his plane. He shot down an enemy fighter and received the Distinguished Flying Cross. In a recent interview, Warth talks about the fifteen months that he spent in England, flying those eighty-two missions. He remembers his English tour as tough. He lost good friends and came close to losing his own life. On one flight, his instruments failed, and he had to "corkscrew through clouds as thick as soup." He said he didn't know what to do, so he let go of the stick, prayed and waited for a clearing, which came when he was three thousand feet from the ground and could already see treetops.

Tom Warth, now in his late eighties, still has all of his war journals. Following is an excerpt from one of his entries:

June 19, 1944: We escorted the bombers on a raid on Bordeaux. I led the quadroon, and the mission went off better than any I have been on in a long time, and they were solid…up to 35,000 feet. I started to climb up through it and come back but someone called and said they were at 33,000 feet and still hadn't broken through it. So, I decided to let down through it and try to find a layer to fly between. I told the other three flights to stay at 18,000 feet, and I would let down and try to find a break. Everything was going fine until I got to about 13,000 feet and started getting iced up. So I started to climb back up. About this time, my instruments went out, and I lost control of my plane. I must have rolled it over and went into a steep dive because before I knew it I was doing 560 mph and had no idea of which end was up. I finally, by the grace of God, saw the ground up above me (I was upside down) and rolled out just in time to keep from cracking up.

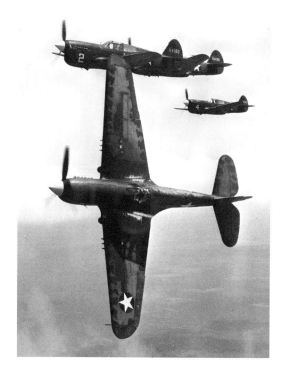

Aerial view of three P-40 single-engine fighter planes in flight. *Library of Congress.*

Tom Warth doesn't like to volunteer much about his war days, artist Chuck Andrews relates. "You have to ask him. And if you do, he becomes a history book with legs."

Who Was Mamie Guyer?

Although we have no specific records concerning Miss Mamie Guyer's boardinghouse, existing reports do show what it was like for a woman to open a boardinghouse in the mid- to late 1930s and the '40s.

By 1935, North Carolina's Piedmont Triad had begun recovering from the Great Depression. In many towns, mills and factories reopened, so men and women looking for work left their homes and migrated from rural areas. In Kernersville, Vance Knitting Company and Adams-Millis Corporation, another hosiery mill, were located within walking distance of Mamie Guyer's boardinghouse, so these became two likely places for employment.

During this time, more and more unmarried, married and widowed Piedmont Triad women opened their homes to factory workers. The typical boardinghouse—such as the Guyer residence—was a large two-story

unheated house that could accommodate as many as a dozen paying guests. The downstairs typically consisted of a parlor, dining room, kitchen and the family's living quarters. The upstairs usually had four bedrooms with as many as three double beds in each—always two men to one bed. A bathroom at the end of the hall contained a toilet, sink and tub but no hot water.

The average cost to most boarders in the '30s and '40s in the Piedmont Triad amounted to three or four dollars per week. This included three bountiful meals a day, served family style. Boarders helped themselves to bowls filled with vegetables, platters of meat or chicken and baskets of homemade biscuits—all placed in the center of the table (hence the phrase "boardinghouse reach").

One of the first public telephones in town stood in the corner yard of the boardinghouse, which sported green paint. A call to Winston-Salem cost five cents.

Perhaps the reason we have no specifics about Mamie Guyer's business results from careless record keeping. Names, nicknames and inconsistent spelling may be the problem. For example, an early Kernersville resident, James M. Guyer, born in Kernersville Township in July 1844 and known as "Judge" Guyer, was a local businessman and justice of the peace. The 1900 Forsyth census for Kernersville shows James M. Guyer (fifty-five) with wife Mary (Bull) Poe (fifty-nine) and Mary G. Bull (twenty) listed as niece. In the 1920 census for Kernersville, Forsyth County, James M. Guyer (sixty-six) is listed with wife Mary J. (seventy) and niece Mamie G. They are shown living next door to James T. Justice.

The search continues. In the 1930 census, Forsyth County, Kernersville Township, we find James M. Guyer (eighty-five) living with niece Mamie (nickname for Mary) Bull (fifty-one). James M. Guyer died on October 14, 1930, but no will is recorded.

Is the name "Mary G. Bull," which shows up in both the 1920 and 1930 census records as "Mammie G," the same person as the Mamie Guyer who ran the boardinghouse on Main Street in Kernersville? Another guess might be that this middle-aged woman decided to adopt the Guyer surname to ensure reputability and dignity for her new business adventure, which would have enabled her to survive financially.

So, some facts are known; however, others are hidden. Did Miss Mamie raise and kill her own chickens in a backyard pen? Did she launder her sheets and pillowcases in a wringer washer on the back porch and hang them on a clothesline with wooden clothespins? Did she chop and split wood for her woodstove?

Unanswered questions leave us wanting to know more.

Dolley Madison

Practically every history buff knows that Dolley Madison was the wife of the fourth president of the United States and was the first lady from 1809 to 1817. Few know of her Piedmont Triad, North Carolina roots, though.

Born in 1768 to starch manufacturer John Payne and his wife, Mary Coles, Dorothea Dandridge Payne, also known as Dolley, grew up in New Garden, a Quaker community located in the area now known as Guilford County. The street where she used to live is now named for her. Dolley later attended Salem Academy in Winston-Salem.

Despite her Quaker upbringing, Dolley developed a vivaciousness and bubbling but sassy personality. Contrary to the Quaker belief in simplicity, she loved dresses with vibrant colors and rich fabrics and fancy feathered turbans. Her friend, Aaron Burr, introduced Dolley to James Madison after Dolley moved to Philadelphia from the Piedmont Triad. On September 14, 1794, she—already a widow and mother of a son, Payne—married James Madison. A warm, charming and gracious hostess, she entertained guests with unusual refreshments, lovely music and interesting conversation. Her

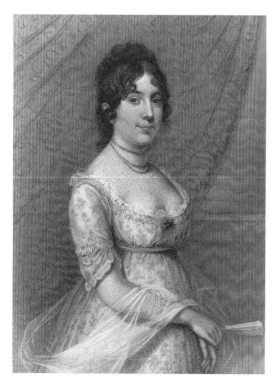

Dolley Madison. *Library of Congress.*

20

People

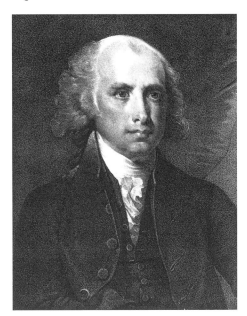

Right: James Madison. *Library of Congress.*

Below: U.S. Capitol after being burned by the British. *Library of Congress.*

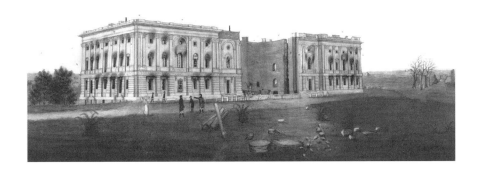

tastes in decorating the White House leaned toward upholstered furniture, luxurious red drapery and American artwork.

Her spunk and determination surfaced one last time when she rescued valuable papers, sterling silver and a full-length Stuart painting of President George Washington from the White House before the British burned it in August 1814. Even though the picture frame holding the painting of Washington was screwed tightly to the wall—and she could not pull it down—she quickly had the frame cut loose from the portrait. Purchased for $800 by the federal government, the painting represented an important symbol of the nation, and she was determined to save it from destruction.

If the American soldiers would do nothing, she would! In her book *First Ladies*, Margaret Truman reveals Dolley Madison's enragement that American soldiers had fled instead of fighting the oncoming British. She even slept with a saber near her bedside should a British soldier appear in the night.

Although she had earlier made dinner party preparations for forty guests, she fled before the British arrived. She had saved many valuable and irreplaceable items. Reportedly, British soldiers ate the meal prepared and then looted and set fire to the White House. The Madisons never lived there again.

Barrino Brothers

Although many are familiar with *American Idol* TV show winner and High Point native Fantasia Barrino and her whirlwind success, few know about the family members who preceded her in gaining national recognition.

Perry, Nate and Julius Barrino, cousins of Fantasia—along with Bobby Roseboro—made recordings for Invictus Records (formerly Motown Records). In an interview, Perry Barrino said that the family talent started with Fantasia's uncle and his father, Curtis Barrino, who was a clown umpire at baseball games. He danced, produced funny sound effects and grabbed the caps of players. "The crowds loved it," volunteered Perry. Curtis also had a serious side, singing in the 1950s with gospel group the Emmanuel Harmonizers.

Music has been important in the Barrino family for years. Perry's younger brother and Fantasia's father sang in a gospel group called Little Godric and the Hailey Singers. Two of Perry's nephews, K-Ci and JoJo Hailey, performed in a rhythm and blues group Jodeci. The Barrino brothers have toured in the United Kingdom and Japan, and Perry attributes their success to versatility.

According to Perry, Fantasia inherited the ability to sing any song with her personal style. As a child, she sang songs by Gladys Knight to get her family's attention. Today, a few of those same relatives exhibit some jealousy at her success. "My desire is that…we can enjoy [our God-given talents]…and come together in a happy accord," Perry said in a 2004 interview. "This is what God wants us to do."

O. Henry (William Sydney Porter)

Most avid readers enjoy reading the work of O. Henry, the pen name of Greensboro, North Carolina writer William Sydney Porter. His short stories are

famous for unique characterization, humor and surprise endings. Those same readers may not be familiar with the forgotten tales associated with his life.

In 1876, Porter graduated from the Greensboro elementary school run by his aunt, Evelina Maria Porter, and entered Lindsey Street High School. When he was nineteen years old, he earned his pharmacist license and began working in his uncle's drugstore, where he also demonstrated his artistic abilities by sketching the townspeople.

When he was only twenty years old, he moved to Texas, believing that the climate would cure his persistent cough. While there he worked as a baby sitter, cook, ranch hand and shepherd. His health improved, and he moved to Austin when he was twenty-one and took various positions as pharmacist, draftsman and bank teller. He began writing, acting and singing with drama groups. He also played the mandolin and guitar. In Austin, he met and eloped with Athol Ester, a young woman from a wealthy Texas family. In 1891, Porter took a job at the First National Bank of Austin as a bookkeeper and teller, but three years later he was accused by the bank of embezzling money; consequently, he lost his job but was not prosecuted.

When Porter's short stories began to catch the eyes of editors, he was hired by the Houston *Post* for twenty-five dollars per month, and when his career seemed to be taking off, he was arrested on charges of embezzlement at the bank back in Austin. Before he could be tried, he fled to Honduras, where he wrote "Cabbages and Kings" (coining the phrase "banana republic" to describe this country). In February 1897, Porter returned to Austin and surrendered to the court. He was found guilty, sentenced to five years in jail and imprisoned as federal prisoner 30664 at the Ohio Penitentiary in Columbus, Ohio; however, various reports indicate that he worked in the prison hospital as the night druggist and never spent a significant amount of time in his cell.

While in prison, he published fourteen short stories using various pseudonyms, but he was best known as "O. Henry." Porter explained the interesting origin of his pen name in a 1909 interview with the *New York Times*:

> *It was during these New Orleans days that I adopted my pen name of O. Henry. I said to a friend: "I'm going to send out some stuff. I don't know if it amounts to much, so I want to get a literary alias. Help me pick out a good one." He suggested that we get a newspaper and pick a name from the first list of notables that we found in it. In the society columns we found the account of a fashionable ball. "Here we have our notables," said he. We looked down the list and my eye lighted on the name Henry. "That'll do for a last name," said I. "Now for a first name. I want something short. None*

of your three-syllable names for me." "Why don't you use a plain initial letter, then?" asked my friend. "Good," said I, "O is about the easiest letter written, and O it is."

So, of course, the rest is history, as O. Henry went on to gain international recognition and credit for defining the short story as a literary art form. In 1952, *O. Henry's Full House*, an anthology film made by Twentieth Century Fox, consisted of five separate stories written by this famous author. One of the stories, "The Cop and the Anthem," starred the famous Charles Laughton and Marilyn Monroe.

Dr. Charlotte Hawkins Brown

The granddaughter of former slaves, Charlotte Hawkins Brown returned to her home state in 1901 to teach rural black children in Sedalia, a town ten miles east of Greensboro and ten miles west of Burlington. When she arrived back in North Carolina from Cambridge, Massachusetts, she walked four miles to the road, where she then rode in a horse-drawn buggy to her new job. The American Missionary Association had hired her to teach at Bethany Congregational Church. An old blacksmith shop served as her classroom.

When that school closed, Charlotte founded the Alice Freeman Palmer Memorial Institute, named for her esteemed sponsor and mentor. A day school and boarding school for African Americans, PMI was the only area school for black children. Charlotte limited the curriculum at this time to domestic and industrial sciences.

In 1937, the elementary portion phased out, and at that time the curriculum focused solely on college preparatory courses. The enrolled students, from wealthy families in this country and six foreign nations, earned the title of "brightest and best" and in 1947 received accolades from *Ebony* magazine.

In addition to her teaching and administrative expertise, Dr. Charlotte Hawkins Brown excelled in community service. The first person in this rural area to enjoy telephone service, she shared this magnificent gift with everyone. Installing a switchboard in the kitchen of her home, she graciously invited everyone to use this convenience.

Other Palmer Institute "firsts" included the installation of electricity on campus, the planting of trees along the drive and the hiring of a host of close-knit Sedalia citizens for various jobs at the school.

After Charlotte's niece, Maria Hawkins, married Nat King Cole in Harlem in 1948, the wedded couple traveled to Sedalia, where they were honored

at a wedding reception in Canary Cottage on campus. Enthralled students rallied around Nat King Cole and his new wife, an alumna of their school.

Dr. Brown's philosophy, in her own words, symbolizes her dedication, intelligence and energy: "The end of all education is to teach one to live completely, to find his highest expression of all that is noble and good."

Josephine Boyd

The same week that the Arkansas National Guard blocked nine Little Rock teens from entering high school there, Josephine Ophelia Boyd became the first black student at Greensboro High School (now known as Grimsley). The difference? Josephine did it alone, and at the time, her actions received no media recognition.

On September 4, 1957, seventeen-year-old Josephine, wearing a brown dress with white collar, walked toward the entryway of Greensboro High School to become a member of the senior class. Along the walkway, students and adults shouted their objections to her decision to enter the previously all-white institution. "We don't want you here!" they screamed. "Go back to where you came from!"

Josephine crossed the threshold that day and every school day for the rest of the school year. She said in a *Los Angeles Times* interview that when she felt alone and unwanted, she recited the Twenty-third Psalm and sang spirituals that helped her focus on not being discouraged when her pain came in the form of alienation and rejection. She admitted that she survived by blinding herself to the faces of the dozen students who tormented her most and by hiding her anger. She graduated from Greensboro High despite eggs thrown on her, ketchup poured in her lap, teachers ignoring her presence, boys spitting in her cafeteria food, snowballs hurled at her, tacks placed on her seat and ink spilled on her books. Once a girl offered Josephine a cup of ice cream, but when she opened the lid, she saw nothing but trash inside. Before her graduation, a telephone caller warned her not to attend the ceremony, but if she did, a coffin awaited her at Brown's Funeral Home.

Josephine's moral support came from her parents, teachers at her former all-black James B. Dudley High School, church members and several white girls at Greensboro High who dared to befriend her. So Josephine persisted even though her family received Ku Klux Klan telephone curses, her mother Cora Lee Boyd lost her job as a housekeeper, her father's sandwich shop mysteriously burned to the ground, her brothers lost their yardwork jobs and someone killed the family's two pet dogs.

A month after her graduation, Josephine accepted an invitation to attend Cleveland's National Association for the Advancement of Colored People (NAACP) convention, where the Little Rock Nine received the organization's distinguished Springarn Medal. Josephine received no recognition, and NAACP officials even asked her "not to crowd the spotlight reserved for the Nine." For Josephine, the memory of a year of degradation and disrespect made her think of herself as "an afterthought." She said, "It made me feel invisible. It wasn't about recognition. It was about equity."

Josephine Boyd's sad story included here is a testament to her courageous struggle.

Betty Feezor

Back in the days when there were only two channels available on Piedmont Triad TV (NBC or CBS), Betty Feezor hosted WBT-TV's (Channel 3) *Betty Feezor Show*. In 1958, this was one of the first shows to be broadcast in color. Betty Feezor has truthfully been called an early Martha Stewart without frills. Betty knew how to sew, cook and accomplish mundane and often boring household chores with the greatest of ease. And she could talk! Never missing a beat, she explained this and that as she demonstrated her skills. She always had her recipe ingredients pre-measured, pre-chopped and pre-grated.

Many housewives copied the recipes shown on the TV screen, ran to the grocery store to secure the ingredients and prepared that particular dish for their families that very evening.

When Betty Feezor became terminally ill with cancer, she told her viewers: "Live so that when you are gone, it will have mattered."

A scholarship foundation was established by WBT and North Carolina Home Economics Association (NCHEA) in 1977 to honor Betty, whose life had touched so many people in the Piedmont Triad. She said of this honor, "It pleases me so much to think that some young person will be able to study for a career in home economics under my name."

Betty Feezor died in 1978. She left a legacy of homemaking, including her famous brownie recipe:

Betty Feezor's Brownies

1 cup margarine (melted in a sauce pan)
1 cup sugar
2 eggs

2 cups flour
½ cup cocoa
1 tsp. vanilla
nuts (optional at about ½ cup or to what you like)

Mix melted margarine and sugar with mixer. Add eggs one at a time. Mix in cocoa and then the flour. Use a spoon to mix in the nuts if you add those. Cook at 350F for 13–20 minutes.

Roy Neal

After retiring as *NBC News* space correspondent, Roy Neal moved to High Point, his wife's hometown, where he continued to entertain captivating audiences with true tales of space flights and crews. These adventures gave Piedmont Triad folks firsthand accounts that they had not heard before about Neal's coverage of all the Mercury, Gemini and Apollo missions, plus many early space shuttle flights.

Neal's son, David, believes that his father had a real talent for telling true stories. David said in one interview: "When he would go to events as a newsman, he would soak up the people, events, and dynamics that made something what it was. He lived in those moments and had an acute appreciation for the moments of history he experienced."

Neal's inquisitive spirit spurred him on as a teen when he built a ham radio so he could learn about people and events in faraway places. He also joined the High Point Amateur Radio Club. He had a fascination and curiosity about everything, and he was adamant that others did also. Consequently, he persuaded NASA to put ham radios on space shuttles so astronauts could talk to their families and also to schoolchildren to keep them abreast of space conditions and experiences. In 1987, Neal hosted the video production *New World of Amateur Radio*, which gave viewers valuable information about how a ham radio worked in space.

Born Roy N. Henkel, Neal died at the age of eighty-two in High Point, North Carolina.

Jesse Jackson

Historians would probably agree that numerous, different demonstrations developed the political skills of Jesse Jackson, but few are familiar with the May 1963 Greensboro demonstration that changed his life.

Jesse Jackson and his followers had just finished a demonstration outside a Greensboro cafeteria one hot day in May 1963. According to reports, the police began moving in to arrest the civil rights leader and his fellow demonstrators. Marshall Frady, author of *The Life and Pilgrimage of Jesse Jackson*, quotes Jackson as he prepared to meet police who would subsequently arrest the demonstrators:

> *We kneeled and started saying the Lord's Prayer. The police took off their caps and bowed their heads. Can't arrest folks prayin'.*

They finished prayer, and the cops again started toward the crowd. The demonstrators stood and sang "The Star-Spangled Banner." Again, officers stopped in their tracks and put their hands over their hearts. ("Can't arrest folks singing the national anthem.")

According to Frady, "They [the demonstrators] were touched by something bigger—something they all respected. It went on like that for thirty minutes; they got tired and let the cops arrest them."

Later that hot May afternoon in 1963, the Greensboro police—having run out of jail space—took approximately 400 students to the dilapidated wards of an abandoned polio hospital on Summit and Bessemer Avenues. The deserted barracks-like building, meant to hold only 124 occupants, had demonstrators struggling for fresh air. When Jackson arrived at the old polio hospital, police, dogs and troopers guarded the structure. Those incarcerated inside began to shout to Jackson, "We dyin' from heat in here! You got to help us. Don't let us perish in here."

Jackson shouted back. His words reverberated over the chain-link fence and past the police with dogs: "We'll get you out; we'll get you out! They can't stop us! We'll set you free!"

Tears and sweat from the bright sun ran down his face. Then he began delivering an impromptu speech, poignantly focusing on all the suffering involved with the civil rights movement, a turning point in the history of our nation.

When he finished, one of the people who had joined the crowd asked Jackson if he would repeat his speech into a tape recorder. "What did I say?" Jackson responded. He did not remember. He explained that some voice and authority beyond himself had taken over.

Jackson later commented on the effectiveness of the 1963 demonstration: "Birmingham had the fire hoses and bombings, but the demonstration in Greensboro was really bigger."

Lunsford Richardson

A pharmacist in Greensboro at the turn of the twentieth century, Lunsford Richardson made medicines to heal minor ailments. His biggest-selling remedy was Vicks Croup and Pneumonia Salve. We know it today as Vicks VapoRub. His discovery came about when he experimented treating his three children who all suffered from bad colds.

Richardson first applied a poultice—a cloth containing warm medicine—on each child's chest. Then he used a vaporizer lamp, which helped circulate the medicine. Treating his kids, Richardson thought of a new and better treatment: a salve. He experimented, mixing oil of eucalyptus, menthol, camphor and other ingredients, and when he further tested the salve by rubbing it on congested persons' chests, natural heat from their bodies released all the medicines and made their breathing less labored.

Having discovered this new medicine, Richardson needed to give it a name before he tried it on the market. He decided against using any part of his own name and subsequently labeled the product Vicks salve after his brother-in-law, Joshua Vick, because he thought that customers could remember that more easily. And remember they did!

Once customers tried Richardson's new product, they came back for more, so in 1898 Lunsford Richardson founded the Lunsford Richardson Wholesale Drug Company. In 1907, the product became Vicks VapoRub. A successful marketing followed with demonstrations and newspaper coupons. In 1922, five million people in rural areas west of the Mississippi River received free samples.

When Richardson died in 1919, Vicks VapoRub sales topped $3 million, a great deal of money for that time. When Richardson's son died in 1972, sales had risen to $450 million. Pharmacies still sell Vicks VapoRub today.

John William Coltrane

Legendary jazz saxophone player John William Coltrane grew up in High Point, where, at the age of thirteen, he played clarinet and the alto horn in a community band. As a young man, he volunteered his talent by performing in a local African American church. After graduating from high school in 1943, he moved to Philadelphia and began his study of the saxophone at the Ornstein School of Music and Granoff Studies. In 1947, he changed from alto to tenor saxophone, and for the next ten years, he toured professionally with various bands.

During the 1950s, Coltrane dedicated many of his recordings to his first wife, Naima Gibbs. At this period in his life, Coltrane's career became entangled with alcohol and drug dependence. He embraced Islam, an experience that reportedly led him to overcome his addictions to heroin and alcohol. In 1960, he formed the Classic Quartet with McCoy Tyner, Elvin Jones on drums and Jimmy Garrison. This group eventually grew to eleven men, with his second wife, Alice McCleod, at the piano. A devout man, Coltrane recorded albums of religious compositions, including, perhaps, his most famous in 1964—*A Love Supreme*.

This four-part suite vivifies Coltrane's faith in and love of God, but as Coltrane himself explained in the liner notes of his album *Meditations*: "I believe in all religions." The fourth movement of *A Love Supreme*, "Psalm," is actually an original poem to God, written by Coltrane and found in the album's liner notes. Interestingly, Coltrane plays one note for each syllable of the poem—an extremely challenging feat according to jazz experts. Ironically, considered one of his finest works, *A Love Supreme* was performed live only once, in Antibes, France, in July 1965.

Suffering from liver cancer, John Coltrane died in 1967 at the age of forty. He had recorded thirty-seven albums during his short life. The National Academy of the Recording Arts and Sciences presented him with posthumous Grammy and lifetime achievement awards.

In the 1990s, the United States Postal Service also honored his memory with a commemorative stamp for his contributions to jazz contemporary, classical and rock music. In addition, he received a posthumous "Special Citation" from the Pulitzer Prize Board in 2007 for his "masterful improvisation, supreme musicianship, and iconic centrality to the history of jazz."

Big Jack Armstrong

Personable and friendly, Big Jack (aka John Charles Larsh) held a Guinness World Record in 1971 for "fastest talking human alive."

Big Jack did not consciously aspire to be a Piedmont Triad motormouth. In fact, he enrolled in Greensboro's Guilford College pre-med course but dropped out as soon as he landed a radio job at WCOG. Not long after, he went national and became a huge hit.

One of his imaginary sidekicks, the Gorilla with a raspy voice, liked women, banana juice and whiskey. The other persona, the wheezy Old-Timer, told corny jokes. Big Jack often talked so fast that no one could really understand what he said, but his audience enjoyed listening to him, especially as he whirled through this garble:

People

People who live in glass houses shouldn't…A bird in the hand makes it hard to blow your nose. One good turn takes most of the blankets. You can lead a horse to water, but don't push him in. Nothing smells any worse than a wet horse, or you can lead a horse to water, push him in and teach him the backstroke, then you've really got something….

Larsh died at the age of fifty-three on March 22, 2008, at High Point Regional Hospital.

Mary Lou Andrews Blakeney

Her true story is amazing and one that many in the Piedmont Triad have not heard.

Several days after the first sit-in at the Greensboro Woolworth's store, four high school students in High Point asked a minister, Reverend B. Elton Cox, and a retired teacher, Miriam Fountain, where the four North Carolina A&T students got their courage to oppose segregation at the Woolworth lunch counter. Brenda Jean Fountain, Miriam Lynn Fountain, Andrew Dennis McBride and Mary Lou Andrews wanted to do their part to end segregation in High Point.

The first planning session, led by Reverend Cox at Pilgrim Congregational Church, produced a variety of responses from those students attending. Some, who did not agree with Martin Luther King's nonviolent philosophy, did not stay for the training sessions, which included role-playing, safety and acceptable behavior.

On February 11, 1960, the twenty-four students who had completed all the preliminary preparations met at the Fourth Street YMCA/YWCA for prayer. At four o'clock, Reverend Cox and Reverend Fred Shuttlesworth led the group on their march to the downtown Woolworth's. They went in the back door of the store, divided into groups and strolled toward various counters. Then the signal came. Reverend Cox doffed his hat, and the group hurried to the segregated lunch counter and took all available seats. The ones that were taken quickly emptied.

Mary Lou recalls what came next: "We made our move. With all seats occupied, some of the students began to study or do homework. Education was always first! This was preached by parents, school, and Rev. Cox."

A waitress first asked the group to leave, and then the manager called the police. According to Mary Lou, "Attempts to strike, kick, push, or pull students began, while the hate-filled crowd yelled racial slurs. Police looked on…but we remained calm and nonviolent."

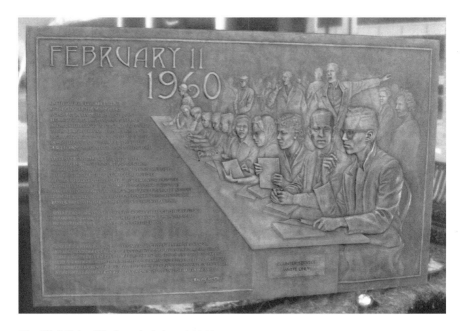

The High Point Woolworth sit-ins of 1960.

About that time, the lights went out, and an announcement rang out that the store was closing. The students left, singing "We Shall Overcome." Even though the crowd that followed them belted them with snowballs, they walked with their heads high through their black neighborhood on Washington Street and back to the Y.

"We made a vow to return," Mary Lou states.

> *When we did, we found the lunch counter seats roped off, so we stood behind them and sang…only to return over and over and over again. This movement extended to other High Point stores, movie theaters, fast-food restaurants, churches, and City Lake Park. It continued for eight years, at which time the Human Relations Commission was formed of black and white citizens.*

George Preddy

Born in Greensboro in 1919, George Preddy learned to fly before World War II. He entered the military in 1940, serving in the U.S. Army Air Force as a fighter pilot for the 352nd Fighter group. By 1943, he had been transferred

to England, where he, in a P-51 Mustang, escorted B-17 and B-24 bombers into Germany.

Considered by veterans as one of America's deadliest fighter aces, he is today listed on the roster of United States' top fighter pilots—one of Piedmont Triad's hidden treasures.

On August 6, 1944, he shot down, within five minutes, a total of six German fighters. He returned on leave to his hometown in 1944. On Christmas Day in 1944, Preddy was back in the skies over Belgium, chasing German planes in his P-51 Mustang. An American team on the ground missed its target, the Germans, and hit him by mistake.

When asked why George Preddy's valiant acts, heroics and skills remain partly hidden, Joe Noah, George's cousin, explained that dead pilots didn't receive many accolades after the war. "He got killed," Noah said. "He wasn't around to talk." Nevertheless, George Preddy had earned the reputation of being one of the best American aces in the European theatre. U.S. Air Force records show him credited with twenty-six victories.

Richard Petty

Richard Petty, stock car racing superstar, hails from the Piedmont Triad and calls Randleman home. Well, not really—if you heed his own words recorded in the 1977 Bill Libby book entitled *King Richard*:

> *What Randleman really is is a township. We live in Randleman, but what we really have is a route number. Our garages are in Level Cross. Always have been, from before they was a garage. That's our mailing address, but what telephone calls we get come through the switchboard in High Point, down the road a bit. They have a downtown there, and that's where we bank and shop and go to the picture show or go out to eat when we want to do those things. There's nothing fancy there. The fancy stuff is in Greensboro.*

Stock car enthusiasts are familiar with Petty's driving skills and his ruthless urge to win. His passion for racing came at an early age. He and his brother, Dale, made a bicycle course on a road that looped up and down through the woods. Then they added a mudhole. Even as boys, they raced hard and got dirty, so they went to their favorite swimming hole to wash their bodies and also their clothes, which they dried in the sun and put back on.

Perhaps many don't know of Richard Petty's gentle and unpretentious nature, his devotion to his family or his graciousness toward his loyal fans.

When asked to sign his autograph, he does so without hesitation. Desiring his signature to be unique—and even a bit fancy—he took a handwriting course so he could offer fans something distinctive.

Wanting his immediate family to attend Daytona Beach's Speed Week, he flew his wife, Lynda, and his kids in for the event. Family has always been important, even from way back. In 1943, when Richard was only six years old, the Petty house burned down. Instead of feeling sorry for himself, he looked at this tragic situation with a philosopher's eye. "Maybe it was lucky that we didn't have much because we didn't have much to replace," he later mused.

Jule Gilmer Körner and Polly Alice Masten Körner

When people reminisce about Körner's Folly, they usually think of "the Strangest House in the World" right in the heart of Kernersville, North Carolina. True, the twenty-two rooms spread over seven levels on three floors are impressive, as are the ceiling heights ranging from five and a half feet to twenty-five feet, the ten-foot doorways, fifteen fireplaces and the decorative

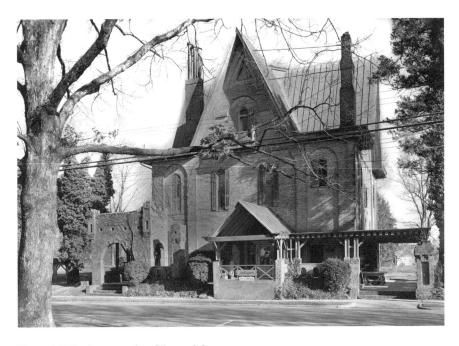

Körner's Folly, front exterior. *Library of Congress.*

murals and woodwork that adorn each and every room. Then there is the winding staircase that goes from one level to another. No two rooms are alike.

The hidden history therein concerns not the house, but rather the couple who owned it. Now, there's uniqueness with a capital "U."

Jule Körner, a handsome young bachelor and interior designer, started building his new home on Main Street in Kernersville. Construction, estimated at over $100,000, was obviously extremely slow, and a cousin rode by the partially finished house, marveled at the strangeness and even remarked, "Twenty years from now, this house will be Jule Körner's folly." Jule liked that different tag and placed an ornate plate in the front of his abode, thus officially naming the house Körner's Folly. He also built a "witches' pot" outside the front door. Before guests entered the residence, they put a coin in the "witches' pot" to lure evil spirits to the coin rather than to the home. According to tradition, this act would prevent the house from being haunted.

Years passed, and finally the house was considered finished in 1880. When Jule married Polly Alice Masten in 1886, he decided to convert the interior stables into a drawing room and library. He turned the drive-through carriage way on the first floor into a dining room and also made playrooms for the children that the couple hoped to have. Folly furnishings became the catalog for the Reubin Rink Interior Decorating and Home Furnishings Company—to showcase his designs that a craftsman had built.

Jule turned the original kitchen into a smoking room. This was the only room in the house where family members or friends could smoke, but they had to sit near fire-safe tile and be sure to extinguish all flames before they left.

In the Great Hall, Jule designed "courting chairs" for unmarried couples. One had a spot for the male. Facing the opposite way, a seat for the female prevented any hanky-panky; to ensure celibate courtships, a third seat existed for the couple's chaperone. As the lovers' relationship intensified, the couple was permitted to "court" in the double-seated courting chair. There was no chaperone here.

Believing that engaged courting couples should ultimately have privacy, he enclosed two "courting closets" with curtains on each side of the Great Hall.

Probably the most interesting hidden story concerns Jule searching for roofing material for the Folly. He found a chestnut tree—large enough to make the shingles he needed—so he offered to buy the tree from the owner. When the farmer declined to sell, Jule bought the entire farm. These chestnut shingles remained on the Folly until 1954.

Polly Alice (who went by Alice) also had very definite ideas for their home. In the large attic space that she named Cupid's Park, Alice opened the first

privately owned theatre in America, the Children's Little Theatre. Her idea came about when a local girl was denied a community meeting place to give an elocution presentation because playacting was thought to be sinful. Alice proudly presented her recital at the Folly. On Saturday mornings, local children met in the third-floor theatre to present original plays. Jule built a stage, which was encircled with rods and velvet curtains. Four kerosene lanterns provided footlights. Jule painted props and scenery for these presentations. Alice, an accomplished seamstress, made costumes.

Alice opened the Folly's Cupid Park to children and offered them, at no charge, the same tutors who taught her two children. Called "the Children's Lyceum," these classes had over forty children who read Shakespeare, wrote plays and recited and performed music. She was, indeed, an early patron of the Piedmont Triad arts.

Probably the most humorous hidden story concerns the Folly's outhouse. Jule and Alice did not have indoor toilets, so a double-sided, double-seated brick outhouse could accommodate up to four people at one time. A waiting

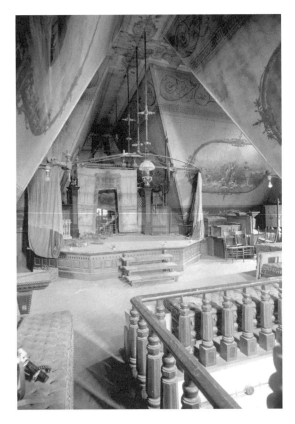

Alice and Jule Körner's "attic" theatre, which was the first privately owned theatre in American and also the birthplace of the Children's Little Theatre. *Library of Congress.*

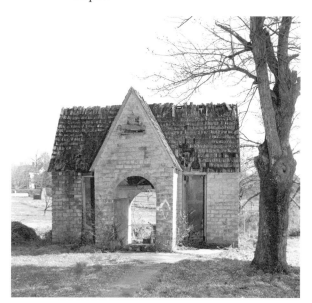

Brick outhouse at Körner's Folly. *Library of Congress.*

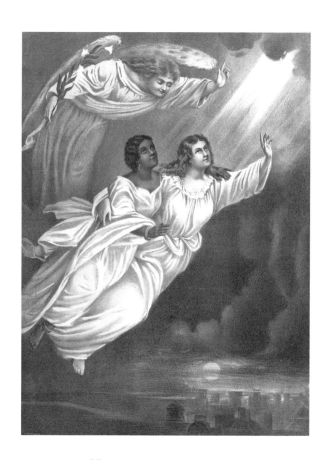

Currier & Ives—*Spirit's flight. Library of Congress.*

room divided the two sections. The roofline of the privy matched the Folly. Elegant for its time, the inside of the outhouse had the same lavish decorations as the residence.

Old Salem's "Little Red Man"

The Single Brother's House, sometimes just called Brother's House, is part of historic Old Salem Village and Gardens in Winston-Salem. Years ago, the building in the old Moravian village was a communal home for unmarried men.

On March 25, 1786, a shoemaker, Andreas Kresmer, was killed while digging a new foundation for an addition to the Brother's House. Late one night, a huge chunk of dirt toppled on Brother Kresmer and smothered him.

Years after this horrible accident, the building became a home of Moravian widows. The story goes that one day a deaf child went to visit her grandmother, who lived at the widows' home. Although Little Betsy could not hear, she could speak but did not know the story of the resident ghost.

Little Betsy rushed inside from the garden and told her grandmother about a little man in a red cap who had motioned for her to join him in play.

One ending to this ghostly tale asserts that at one point a minister came to lay the ghost to rest and the Little Red Man has not been seen since. Even today, some people say that they occasionally hear his shoemaker's hammer and spot him in his red cap, running through the halls of the old Brother's House.

PART II
PLACES

Historic Jamestown

The Keyauwee Indians lived in the area known as Jamestown as early as 1701; however, recent archaeology digs have produced evidence of human habitation from thousands of years ago. The climate, natural resources and hunting grounds accounted for this area's popularity.

Richard Mendenhall, a tanner, built his historic homestead, Mendenhall Plantation, in 1811. By this time, Jamestown had become a settlement of over 150 citizens. A post office, inn, Masonic Lodge and even several gold mines added to the comfort of residents in this small, quiet Quaker farming village.

Opposing the Civil War, Quakers in Jamestown organized a secret way to help slaves escape to freedom. First, they built special trapdoors that led to their basements. Slaves temporarily resided in these hidden cellars. Next, Quaker men built special false-bottom wagons to transport in secrecy many African American servants to freedom in the North. Today, Mendenhall Plantation has on display one of these original wagons.

Ironically, these same peace-loving Quakers in Jamestown were also given two choices during the Civil War: make shoes, uniforms and weapons or pay high taxes.

As early as 1817, medical students lived and studied in the Madison-Lindsay House, the state's first medical school. Dr. Shubal Coffin opened the second medical school in 1840. The Neoclassical-style "Old Schoolhouse," built in 1915, now houses the Jamestown Public Library and regularly hosts regional writers for festivals, readings and book signings.

Early Jamestown also boasted a Quaker children's school, a seminary for young women and a law school for young men.

British general Cornwallis and his army camped near Jamestown during the Revolutionary War in 1781. They demanded food from local farms and grain from mills before battling with Nathanael Greene's troops at New Garden.

Friend's School and Meetinghouse, Jamestown. *Library of Congress.*

Mendenhall Counting House, Jamestown. *Library of Congress.*

Other forgotten historical information might include the following facts: an early Jamestown factory produced the highly collectible Jamestown rifle, a muzzleloading gun; a man named F.L. Bevan lived in the historic William Reece House and trained dogs for J.P. Morgan, Jay Gould and Pierre Lorillard; and Jefferson Davis and his soldiers made their way through Jamestown in a Southern retreat at the end of the Civil War. Most people would not remember the Mendenhall Counting House in Jamestown. This today would be called an accountant's office, which would have handled financial transactions such as collecting rent, auditing and paying bills.

Blandwood Mansion

Blandwood Mansion, now owned by the John Motley Morehead Commission and maintained by Preservation Greensboro, is opened to the public for tours and special events. The forgotten history behind the house and its owners is fascinating and goes back a long way.

Charles Bland built the original Federal-style farmhouse even before the founding of Greensboro in 1808. The next owner, Henry Humphries, expanded the existing residence to six rooms. By 1828, Humphries, touted as the wealthiest man in Greensboro at that time, owned the first steam cotton mill in North Carolina.

From age sixteen to nineteen, the third owner of Blandwood, John Motley Morehead, studied with Dr. David Caldwell at the log cabin school, attended the University at Chapel Hill and subsequently read law with highly esteemed attorney Archibald Murphy. Elected governor of the state of North Carolina, Morehead served two terms. During his time in office, his progressive policies included improving rail and water transportation systems, providing free public schools and demanding better care for the mentally ill, blind and deaf children and prisoners. For his innovative work, he earned the title "Father of Modern North Carolina."

Living in the six-room farmhouse for years with his wife and eight children, Morehead decided that it was time to expand. In 1846, an addition—completed by architect Alexander Jackson Davis (co-designer of the capitol)—doubled the size of the original residence. Built in the Italianate style, this is, according to sources, the oldest surviving example of this style in the United States. After the deaths of Governor and Mrs. Morehead, Blandwood went to their youngest son and then passed on to a daughter, Emma Morehead Gray, who built more additions to the existing structure.

When Emma died, her remaining siblings eventually sold Blandwood in 1906 to the Keeley Institute, an organization that treated people with drug and alcohol addiction, and Keeley operated there until 1961. Five years later, when the house was scheduled for demolition, the Greensboro Preservation Society restored this historic landmark—a ten-year project—and today the public can enjoy tours.

White Mulberry Trees in the Land of Eden

In 1728, when William Byrd and his survey party set out to mark the boundary line between Virginia and North Carolina, they arrived at a spot that Byrd

named the Land of Eden. Immediately, he foresaw many possibilities for this beautiful spot. He would graze cows; grow hemp, flax and cotton; and plant grapevines and fruit trees. These dreams were not uncommon among early explorers and planters; however, Byrd had a unique plan. Over his twenty-thousand-acre estate, he would plant white mulberry trees to feed silkworms, which would eventually cultivate raw silk.

Today, Eden, North Carolina—located an equal distance from the mountains and sea—boasts water, not silkworms, as its major asset. Two rivers, the Smith and the Dan, plus smaller streams—Buffalo Creek, Matrimony Creek, Tackett's Branch and Cascade Creek—have been credited for Eden's economic growth.

Central Carolina Convalescent Hospital

Some people may recall the polio epidemics of the 1940s, but others may not know the severity of the disease in the Piedmont Triad or the heroes involved in building Greensboro's Central Carolina Convalescent Hospital to treat stricken children and adults. Following a paper trail proves hopeless because patient records perished in a later fire; however, those who remember the hospital during the summer of 1948 have partially recreated events.

In 1948, polio struck 2,516 North Carolina children. In Guilford County, 40 new cases in June prompted citizens to construct a medical treatment facility. According to reports, citizens originally planned to build the Central Carolina Convalescent Hospital as a temporary institution for polio patients. The projected cost of $60,000 soon became $175,000 because medical personnel expressed a pressing need for a permanent 134-bed facility in July.

Word spread throughout Guilford County, and money totaling over $100,000 poured in. In addition, various companies and private citizens donated their time, talents and services to build the hospital "stat." Those in charge chose a building site—an East Bessemer Avenue/Huffine Mill Road tract of land, originally part of the World War II Overseas Replacement Depot base that had closed in 1946.

In only ninety-four days, both union and nonunion volunteer workmen labored a total of eleven thousand hours, completed the hospital and admitted polio patients, who quickly filled each of the beds.

Treatment could be grueling. Fluid, collected in small test tubes from a puncture made in the lower back of the afflicted person, was used to determine the white blood cell count. The Sister Kenny hot pack method,

named after an Australian nurse who belonged to a Presbyterian (not a Catholic) sisterhood, proved helpful in relieving spasms of affected muscles. Kenny packs, consisting of woolen army blankets boiled and wrung dry, provided penetrating heat to patients' affected limbs. Hydrotherapy in a floatation tub containing one-hundred-degree water enabled polio victims' chests to be covered, thereby treating paralyzed muscles and nerves.

Patients with severe cases of polio needed oxygen inhalators. Tubes extended from their mouths and collected saliva, which they could not swallow because of paralyzed throat muscles. Blood plasma was given to patients suffering from the brain type of infantile paralysis. Those whose respiratory systems had become paralyzed were placed in iron lungs.

The Central Carolina Convalescent Hospital records may have been destroyed, but we know that doctors, nurses and volunteers saved many lives in 1948.

Gristmill, Textile Mill and Railroad Repair Station

In 1748, Jacob Trollinger built one of the first gristmills in Haw River, North Carolina. Toward the end of the Revolutionary War, when Lord Cornwallis and his soldiers confiscated Jacob's grain, he confronted the redcoats. They, in turn, tied him to a tree and put a bridle bit in his mouth. To get even, he sent a slave and two of his sons to fight the British.

Jacob's brother Benjamin built Granite Mill in 1844, which marked the beginning of the textile industry at Haw River and today remains the only

An old gristmill, where grain was taken to be ground. *Library of Congress.*

antebellum mill building in Alamance County still in use. To ensure local railroad service in 1849, Benjamin also constructed, at his own expense, the railroad bridge over the Haw River.

Benjamin Trollinger then needed a place to repair and service trains, so he went a few miles west to Company Shops (the real name of the town back then—it later became part of Burlington, North Carolina) and was instrumental in getting a railroad repair station located there. According to one historian, in the spring of 1865, bales of cotton and kegs of gold—sent out hastily but consigned to no one—arrived at Company Shops. Residents unloaded the cotton for their personal use. No one knows what happened to the gold. Stories and rumors continue to this day. Some speculate that much of the gold was buried, and people have found coins near the rails. Strangers with shovels appear from time to time. The fate of the gold remains a puzzle to this day—a true hidden history.

The Old Hardware Store

The wooden floor creaked as customers entered Piedmont Triad's old hardware store. The owner and his helpers greeted all with a jovial "Good mornin'! What can we do you for?"

Before any real business was transacted, there was talk of politics, what new was happening in the area, taxes, who happened to be ailing and who had died, who was hitting the bottle and just about anything under the sun. You see, the old hardware store was definitely a man's world when it came to subjects of conversation. Women seldom shopped there.

On the right wall of the old hardware store, merchandise was stacked on ceiling-high shelves. Tall rolling ladders reached from floor to ceiling. Fan belts and other hanging merchandise dangled from the ceiling.

Plumbing supplies lined the narrow aisles. If someone needed plumbing advice, he probably got more than he bargained for. If he had an electrical problem, that, too, could easily be solved. Talking about fixing something was probably just as important as purchasing the necessary equipment or even completing the job.

Musty iron, copper and rubber odors permeated the building. A potbellied wood stove warmed the interior during winter, and the open front door—and perhaps a couple of huge fans—cooled during summer.

Small, numbered drawers held screws, nails, tacks, brads, hinges and other necessary hardware. A front counter with glass display windows contained light bulbs and other breakable items.

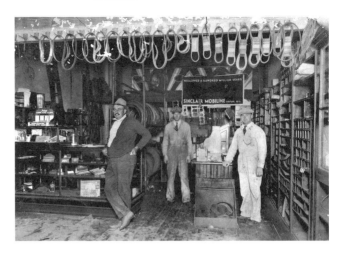

An old hardware store, where just about anything could be found and purchased.

A sign to the right of center advertised Sinclair Mobiline Motor Oil, promising that the product had mellowed for one hundred million years.

Any kind of tools and household item could be found at the friendly hardware store, but there was more. Colorful tins, cast-iron cookware and biscuit jars containing candles shared shelf space with any type of gadget imaginable.

For those who wanted "belly-washers" while shopping, glass bottled soft drinks were available for five cents each. Tall tales didn't cost anything.

Overseas Replacement Depot

The Overseas Replacement Depot (ORD) in Greensboro during World War II played an important role in the logistics involved in deploying equipment and over 300,000 military men and women.

On approximately five hundred acres that the U.S. government leased, military personnel trained soldiers in some of the buildings (still standing) and then transferred them to various assignments at home and abroad. The main entrance to the ORD training grounds boasted a wide, arched wooden gate with small arches on either side. A sign at the top of the entranceway read "ARMY AIR FORCE." Below that a smaller sign said "OVERSEAS REPLACEMENT DEPOT." Surrounding the gate and extending beyond, huge trees shaded the main road leading to the training grounds and living quarters.

Greensboro Section N, Branch 2, 1060th ORD recruit Corporal Rayman Williamson sent a picture postcard dated October 5, 1944, to his friend Jack, stationed in Selfridge, Michigan, with the following interesting message:

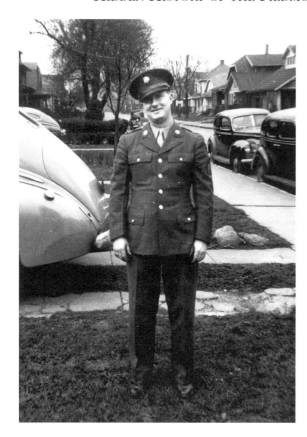

Left: A World War II soldier in uniform.

Below: A World War II soldier getting a haircut.

Hi, Jack:

Arrived here OK and they are giving us plenty of H…Stay at Selfridge as long as you can. Look to leave here real soon. Have you married your cousin yet?

Regards,

Rayman T.S.P.O.E. No Fooling

The postcard bore no stamp but instead had the handwritten word "Free" where postage normally went. Greensboro's ORD processed soldiers back to civilian life in 1946 after World War II. A section of the city near Lindsay, Bessemer and English Streets still goes by the name of ORD.

Thomasville's Treasures

Everyone associates Thomasville, North Carolina, with two distinct symbols: the "Big Chair" and the oldest railroad depot in the state. These two treasures stand proudly just a few hundred feet from each other. Many, however, do not remember how or why these icons became associated with the Piedmont Triad city of Thomasville.

The "Big Chair," a thirty-foot replica of a Duncan Phyfe armchair, has a place of prominence in the middle of the city. Built by the Thomasville Chair Company in 1922, this giant piece of furniture consisted of lumber and Swiss steer hide. Worn and torn by exposure to inclement weather, the original was demolished in 1936. Finally, in 1951 a larger concrete replacement took the place of the 1922 version and has even been featured on *Ripley's Believe It or Not!* Residents will argue unabashedly that this is the largest chair in the world. When Lyndon B. Johnson toured Thomasville as a presidential candidate in 1960, he stood beneath the "Big Chair" during a whistle stop.

Natives also brag about their railroad depot being the oldest in North Carolina. In an article in the July 28, 1921 *Chairtown News*, Mrs. John T. Cramer, daughter of Thomasville's founder, John W. Thomas, writes about the celebration of the completed railroad. The townspeople, dressed in their finest clothes, had prepared a big barbecue to welcome the first passenger train. All scurried in various directions when they heard an earthquake-like roar of the engine and saw their horses escaping to the woods. The train

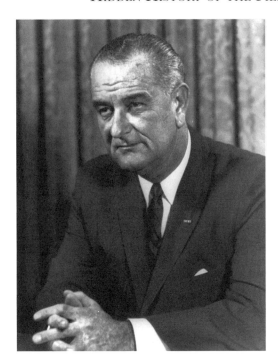

Lyndon B. Johnson. *Library of Congress.*

stopped at a platform in front of the hotel, and passengers and conductor went inside to eat. Expecting a leisurely meal, passengers were hurried back to the train just as soon as the conductor had finished eating. Even on such an eventful day, this dedicated railroad employee demanded that everyone stick to a strict schedule.

Thomasville also hosts an annual "Everybody's Day," the state's oldest festival.

Tanglewood Park

During each Christmas season, thousands of Piedmont Triad families drive through Tanglewood Park in Clemmons, North Carolina, for the festive show of lights. Couples are still married in the 1809 Mount Pleasant wooden church. The Manor House is a bed-and-breakfast inn for meetings and overnight accommodations. The park currently provides a recreational haven with its woods, streams, pastures, gardens and various recreational activities.

Not many people, though, remember the rich history surrounding the area.

Interestingly, in 1584, Sir Walter Raleigh claimed this property for Queen Elizabeth. In 1757, William Johnson purchased part of the original plot and built a fort for protection against French and Indian War attacks. In 1921, Will Reynolds, tobacco entrepreneur, bought the 1,100-acre property and established Tanglewood Farm, where he raised and raced thoroughbred horses. Will's wife, Kate, a horticultural expert, began planting flowers in various gardens.

Kate Reynolds may have been responsible for naming the estate. Accounts indicate that the name came to her one day while she walked through tangled underbrush of cut timber. She wrote this poem about Tanglewood:

> *The seat of creeks and mighty tress,*
> *Of fertile soil and balmy breeze…*
> *Twould fill a page, had I a book,*
> *To tell the joys of Tanglewood!*

Club Kilby

In 1927, Mrs. Ora Kilby Martin, wife of prominent physician Dr. Joseph Alfred Martin, built a two-story building attached to the existing twenty-one-room Kilby Hotel that her parents had completed in 1913 at the corner of Hobson Street and East Washington Drive in High Point.

The new addition became a lively entertainment center called Club Kilby. Ultimately, celebrities such as Nat King Cole, Billy Eckstein, Ella Fitzgerald and Duke Ellington came to play at Club Kilby. How did these famous singers and musicians become a part of an African American nightclub in the Piedmont Triad?

The Martins' daughter Marion had attended Palmer Institute, an exclusive boarding school for black females founded in 1902 in Sedalia by Dr. Charlotte Hawkins Brown. While attending Palmer Institute, Marion became lifelong friends with a student named Maria Hawkins, the niece of the founder of the school. They stayed in touch, and Marion invited Maria's new husband, Nat King Cole, to perform there.

This African American nightspot became a favorite Saturday night hangout for adults. Patrons visited the downstairs bar before going up the wooden steps to dance and enjoy musical magic. Imagine Nat King Cole welcoming people while crooning "Mona Lisa" or "When I Fall in Love" for the eager crowd.

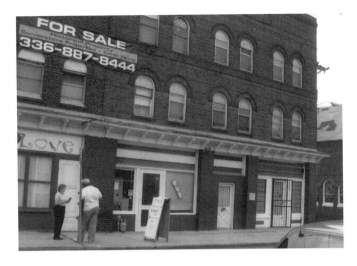

Club Kilby.

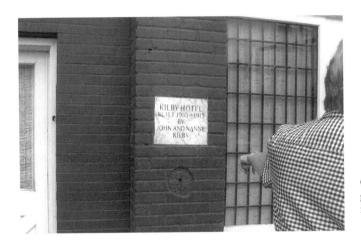

Club Kilby, the gathering place for jazz concerts.

Club Kilby rafters probably shook as Ella Fitzgerald, dubbed "the First Lady of Song," sang ballads or jazz in her flexible and wide-ranging voice. "Love and Kisses" would have brought clubbers to their feet.

To add to the famous list of entertainers, Edward "Duke" Ellington and his top-notch band offered favorites such as "Choo Choo Gotta Hurry Home" (also known as "Chatanooga Choo Choo, Won't You Carry Me Home") and "Rainy Nights Rainy Days."

Billy Eckstein added his magic to the entertainment lineup, as did "Hartley Toots" and his orchestra.

Club Kilby operated until the early 1960s.

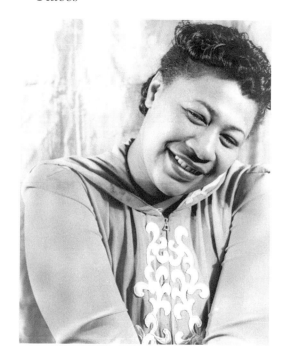

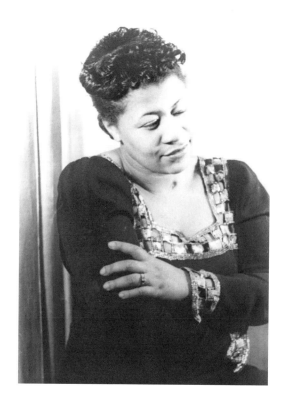

This page: Ella Fitzgerald, the "tisket a tasket" girl. *Library of Congress.*

From Courthouse Ruckus and Gold Mining Days to North Carolina Zoo Site

When asked about Asheboro, most people immediately think of the North Carolina Zoo, touted as one of the best in the country. How many folks remember that one of the earliest forms of entertainment was court-related? In addition, few would have recollections of Asheboro's gold mining operations.

In 1780, the county seat of Randolph County was moved from Johnstonville to Asheboro. On land owned by Jesse Henley, the new relocated court held its first session on June 12, 1793. By 1805, a large two-story frame building, built on the Main Street Square, served as the courthouse at which judges and attorneys conducted their business. The Square also served as a meeting-trading-drinking-yelling place for others.

According to various sources, court sessions produced many people and varied activities. Among the pastimes, horse swapping and drinking grog produced a great deal of party-like noises outside, which often caused the presiding judge to send his high sheriff to the Square and demand that the ruckus stop—pronto!

By 1834, the town had grown and improved. The first weekly newspaper, the *Southern Citizen*, proclaimed Asheboro an "uncommonly healthy and pleasant" village.

Warnersville

This historically African American neighborhood was first settled by Yardley Warner, a Quaker missionary who visited the South toward the end of the Civil War. The area today has only one remaining structure, J.C. Price Elementary School, and one original landmark, the Union Cemetery. A rich history still prevails.

Yardley Warner, a Quaker, wanted freed African American slaves to enjoy positive lifestyles. In 1867, he purchased approximately thirty-six acres of land, divided it into one-acre plots and sold them to black families so they would have the opportunity to experience homeownership and financial security. He earned the name "Freedman's Friend." Soon, frame houses, garden plots, a cemetery, a church and a school sprang up for this new community of six hundred people

By 1873, elementary and secondary school students met in the basement of Warnersville's North Carolina Methodist Episcopal Church. Interestingly,

that first school later became Bennett College for Women in 1926—an institution of higher learning for African American women.

Warnersville, Greensboro's first suburb, soon gained the reputation of being an excellent, self-sufficient model for other neighborhoods in the area. In 1920, J.C. Price School was built and named for the man who was the son of a slave. Many residents became strong community leaders; others held impressive positions at their places of employment. Everyone looked out for one another in close-knit Warnersville.

Angela Harris fondly remembers the old Warnersville and Lola Gant, the "Candy Lady." According to one source, "As a little girl, no more than 7, Harris would jingle the change in her pocket, walk two doors down, buy candy from the 'Candy Lady' and watch her tongue turn purple, red, green, and pink."

Today, widened streets, ranch houses, town homes and apartments have replaced the stores, St. Matthews Methodist Church, the Gem Movie Theatre, grocery stores, doctors' offices and funeral home—situated at the place called Five Point. The neighborhood has been stripped of businesses and historic buildings. Citizens of the old Warnersville area who want to preserve their history are considering renewing spirit and enthusiasm through artistic and colorful totems. Residents have also commissioned Gary Gresko to sculpt five steel and African teak benches, each carved with one of these words: endurance, triumph, faith, strength and hope. These benches will be placed on a proposed 4.8-mile trail, Downtown Greenway.

St. Buffalo Presbyterian Church

Probably one of the most hidden historical spots in the Piedmont Triad is St. Buffalo Presbyterian Church, organized in 1758. To get to the church from Greensboro, history buffs must take Route 29 North, exit off I-40 and follow Highway 29 about five miles until they get to Church Street. Then, they turn left onto Church Street and left onto Sixteenth Street; Buffalo Presbyterian is on the corner.

Of interest here is the Caldwell section of the graveyard. Curious people must continue down the causeway between the two buildings until they reach the cemetery. They should look immediately to their left; close to the building is David Caldwell's grave.

Next comes the question: who was David Caldwell? His rich and fulfilling life also constitutes another hidden Piedmont Triad story.

David Caldwell, who graduated from Princeton in 1761, spent time as a missionary in North Carolina, and after his ordination in 1765, he started a

log cabin school in Guilford County where Greensboro's Bicentennial Park is today. Caldwell's school focused on the teaching of law.

Sources indicate that General Cornwallis offered a generous reward for Caldwell's capture because he spoke out against the Crown during the Revolutionary War. He fled for his life, but not before his house, including everything therein, was destroyed. He and his family hid in their smokehouse and survived by eating dried peaches.

A member of the convention that formed the Constitution of the State of North Carolina, David Caldwell always took an active role in politics and earned the respect of his colleagues. He preached until 1820, often at Hawfields Presbyterian Church, east of Greensboro. He died on August 28, 1824.

Black Walnut Bottom

Historic Bethania in Forsyth County, the sole remaining independent and continuously active Moravian village in the southern United States, contains the only existing Germanic linear agricultural village in the South. About 1759, Gottlieb Reuter surveyed a tract of approximately 2,500 acres of woods and farmland and staked it on the "Black Walnut Bottom" plan.

The name Black Walnut Bottom refers to the type of street layout for villages common in central Europe during the Middle Ages. Families built houses on equal-sized lots that lined a street or road. Next to each house was an orchard lot designed for gardens, farm animals, outbuildings and fruit trees. Common fields—often divided into strips behind the houses—gave Moravians land to raise grain. Others served as woodland or communal pastures. Fences, tree lines and cultivation patterns are evident even today.

According to historical and archaeological reports, Bethania's Black Walnut Bottom community is unique because it is the only Moravian agricultural village that strictly adhered to this European model.

Cone Mills

For most people in the Piedmont Triad, Cone Mills has the fine reputation of being the world's largest manufacturer of denim fabric and the United States' largest printer of home furnishing fabrics. Few know the history behind the mill.

Moses and Caesar Cone, sons of a Baltimore wholesale grocer, had always worked in their father's business. In their travels in 1886, the brothers

observed, with interest, the South's textile industries. Beginning a few years later, Moses and Caesar began investing in cotton mills. About 1895, the brothers built a mill in Greensboro. They named the factory Proximity Cotton Mill because of its convenient proximity to nearby cotton fields.

The progress continued. In 1899, Moses and Caesar opened Revolution Mills, which wove soft cotton flannel, and three years later they constructed White Oak Mill (named for the gigantic tree outside), which turned out indigo blue denim by 1905. After Moses died in 1908, Caesar opened the Proximity Print Works in 1912. This mill "finished" cotton with many colors, creating a product new to the South.

By 1915, Proximity Manufacturing Company—as it was now called—made denim for Levi's jeans, and by 1914, the mill produced products for the Allies overseas. After 1917, it made goods for the American armed forces.

When the stock market crashed in 1929, the company introduced a lightweight fabric called "flannelette" and a crepe named "Proximity Plisse." As the Great Depression moved in, Proximity manufactured a dark indigo fabric. In fact, because so many men wore overalls, denim helped keep the mills open during these hard times.

During World War II, Cone plants produced camouflage cloth, tent cloth and osnaburg for sandbags.

On January 1, 1948, Proximity's name changed to Cone Mills Corporation.

The Proximity Hotel.

In the late 1970s, Cone Mills experienced rising materials costs, lower profit margins and a changing global market. The company hung on for years but eventually filed for Chapter 11 bankruptcy in the fall of 2003.

The historic marker for Proximity is on Wendover Avenue at Church Street in Greensboro, about three miles from the new upscale Proximity Hotel.

Green Street Church

Residents near the Old Salem community held a tent revival in August 1902. At that time, twenty-three people were converted to the Christian faith. Then, on the last Sunday of September, eighteen charter members organized as the Salem Methodist Episcopal Church, South. The congregation bought a lot in the West Salem neighborhood and built a wood frame building. When this overflowed in 1922, they constructed a brick sanctuary on the present location. It wasn't until 1939 that the name of the congregation changed to Green Street Methodist Church.

Now, these trends were not uncommon among early churches in the Piedmont Triad. What happened next, though, constituted a revolutionary historical shift in the church's history.

By 1997, many people had left the church, and worship services averaged only 15 people each Sunday. Under the leadership of Reverend Michael Goode, the 15 members who stayed called themselves the "remnant." They made a bold decision to invest their endowment fund in order to keep the church open, renovate the sanctuary and reach out to the community. This they did, and today the church, led by Reverend Kelly Carpenter, is thriving, with over 250 members.

What caused this explosion of membership, service and renewed dedication? Columnist Nat Irvin explained it this way:

> *There are old folks, middle aged, and young. Blacks, Latinos, gays and straights, and blended families, too. People with tattoos, Mohawks and dreadlocks. Some in college, some with Ph.D.s, M.D.s, no Ds, the do-wells and the we-all-need-to-do-betters. Some wear suits, but most do not.*

Irvin had it partly right; however, lifestyles do not completely define this church's surge in the twenty-first century. Folks are just folks, unless they *do something*. And the folks at Green Street go the extra mile in *doing*.

Eileen Ayuso, executive director of the Shalom (a Hebrew name meaning "peace") Project, has initiated a new chapter of service, a passion for

ministry with people on the margins. While a few of the Shalom programs, such as Bible study, book discussions and spiritual formation groups, are evident in other church communities, Green Street has gone beyond these. The weekly Welcome Table provides meals for the West Salem community on Wednesday nights. An after-school program, Kids Café, gives children of West Salem a safe place to gather four afternoons each week for homework tutoring, computer skills training, recreational activities, cultural enrichment and a nutritional evening meal.

The Food Pantry and Clothing Closet, which serve over seventy people each week, provide emergency nonperishable groceries to people who are hungry and to those who need clothing. The Food Pantry distributes sixty to one hundred bags of groceries as a satellite pantry of the Second Harvest Food Bank. The Clothing Closet receives donations from stores, churches and individuals and distributes them at no cost.

A Wednesday night health clinic provides doctors, nurses and pharmacists who volunteer their time and talents to provide health and medication services for the underinsured and uninsured. A licensed pharmacy fills prescriptions written by the clinic's doctors.

Consequently, the aging Green Street Church building, tucked in the historic West Salem neighborhood, has become a haven where needs are met. Those fifteen people who stuck with the church's mission should be extremely proud!

Saxapahaw: From Mill Village to Upscale Complex

Saxapahaw, a traditional mill village on the Haw River in southeastern Alamance County, got its name from the Sissipahaw Indians, who lived there before white settlers moved in and occupied the land. According to a published history of the village, John Newlin changed the name because his secretary could not correctly spell the Indian word. So Newlin made it easier; he rewrote the name, making every other letter an "a."

In 1844, John Newlin opened a textile mill that supplied the townspeople with work for 150 years. The 1844 mill was later demolished, and a new brick structure took its place and operated until a tornado damaged the building so badly that operations never resumed.

Today that mill, placed on the National Register of Historic Places, has undergone extensive renovations and offers upscale town houses and apartments. The old dye house now contains a general store, charter high school, salon, wellness center and offices. Revitalization has also come in

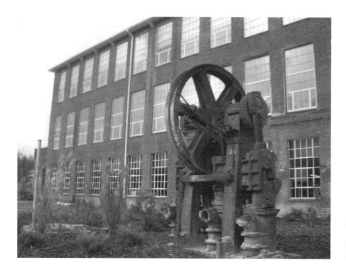

Upscale town houses and apartments, Saxapahaw Mill.

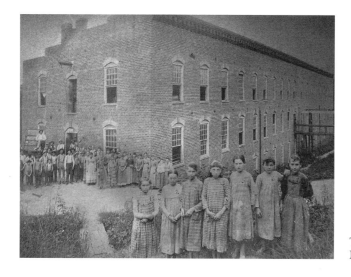

The old Saxapahaw Mill and workers.

the form of the Redbud Festival, an annual bluegrass festival. Other events include a farmers' market, music series and variety of children's activities.

Cooleemee

What a strange name for one of the Piedmont Triad's finest plantations. Hidden history reveals how that came about. In 1817, Major Peter Hairston bought 2,570 acres from General Jesse A. Pearson for $20,000. These tracts

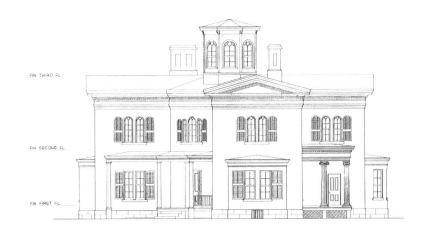

NORTHEAST ELEVATION
SCALE ³⁄₁₆" = 1'-0"

J.C. BUIE, J.A. KREPS, DEL. 1963

SCHOOL OF DESIGN	NAME OF STRUCTURE	SURVEY NO	HISTORIC AMERICAN	INDEX NO
NORTH CAROLINA STATE COLLEGE UNDER DIRECTION OF UNITED STATES DEPARTMENT OF THE INTERIOR NATIONAL PARK SERVICE, BRANCH OF PLANS AND DESIGN	COOLEEMEE PLANTATION HIGHWAY 64 - NEAR MOCKSVILLE - DAVIE COUNTY, NORTH CAROLINA	N.C. 212	BUILDINGS SURVEY SHEET 7 OF 14 SHEETS	

Cooleemee Plantation, Mocksville. *Library of Congress.*

were already named Cooleemee because Pearson had camped with an Indian by that name on a military campaign. Apparently, he liked the sound of it.

The Cooleemee Plantation House, located between Mocksville and Lexington, took over two years to build at a cost of $10,438.31. In the shape of a Greek cross, with four wings coming off the front hall, the house boasts a spiral staircase built to sweep in curves to the roof's cupola. Its designer and architect was W.H. Ranlett of New York.

Fifty feet high and requiring over 300,000 bricks—burned in a kiln on the plantation—the house's foundation consists of native rock overlaid with those bricks.

The landscaping, with English boxwood, stone gateposts and wrought-iron fence, lends an antebellum touch to the grounds. Living at Cooleemee required outbuildings, consisting of carriage house, stables, milk barn, dairy, chicken house, granary, corncrib and kennel. The kitchen was separate from the house.

One of the most interesting aspects of Cooleemee's hidden history concerns the complex lineage—that of both black and white members of the Hairston clan. They have accepted one another as one family, gather for reunions and share their stories and feelings about slavery, emancipation, lynching and civil rights.

Wright Tavern

Wentworth, founded in 1798, is today the smallest county seat in North Carolina. Old homes, churches and the restored Wright Tavern provide the perfect nineteenth-century village atmosphere.

As Rockingham County's center of government, Wentworth hummed with political activity. Wright Tavern opened in 1783 when owner James Wright received a license to keep a tavern in his dwelling. Later, in 1816, James's son William built the original part of the still-standing tavern.

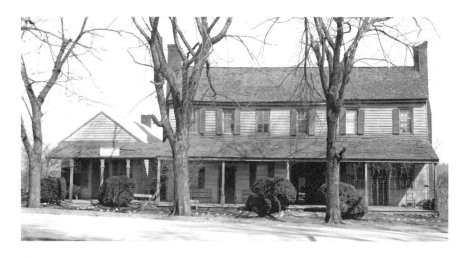

Wright Tavern, Wentworth. *Library of Congress.*

Wright Tavern, Wentworth, offering the finest in lodging. *Library of Congress.*

Near the courthouse and the only known tavern in the area serving meals, this business thrived as lawyers, judges and political leaders enjoyed the interesting conversations and hospitality found there.

Unique to the inside of the tavern was a "dog-run" or open center, usually reserved for log cabins and extremely rare in a frame construction. The interior of the two-story, four-bay house/tavern had hand-carved trim, fine wainscot and beautiful floor grains in the front room, parlor, dining room, family room and boarding rooms reserved for overnight guests.

An exterior kitchen with solid rock floor stood separately from the main structure. The log smokehouse, grain crib and lumber barn dotted the backyard, where a fire wagon held water in case of emergencies.

Hospitality and comfort abounded at Wright Tavern.

Sosnick & Thalheimer

Sosnick Department Store (or Sosnick's) in Winston-Salem provided the ultimate shopping experience. Just when shoppers thought that nothing could be better, Sosnick's was purchased, and shares of Thalheimer Brothers stock were traded on Wall Street for the first time—the name was then changed to Thalheimer's.

Located in the heart of downtown Winston-Salem, Thalheimer's became the *piece de resistance* of luxurious shopping in the 1940s and '50s. Specialized departments, created on separate floors, had female clerks dressed in professional black attire. With hair coiffed and make-up applied to perfection, they served and pleased customers. In addition, male clerks wore conservative suits, starched shirts and silk ties. All met each customer with grace and dignity and promised individualized service.

The elegant bridal salon provided gowns of every style for every age. Glittering displays amid special lighting resembled a "wedding wonderland." Clerks knew how to coordinate the bridal gown with the bridesmaids' dresses and with the mother of the bride's attire. Alterations sometimes came free with the cost of the garment. The bridal salon, tastefully showy, offered the finest in beautifully dressed and elegant mannequins—from gown to veil to accessories. A trained consultant delivered neatly pressed gowns to the wedding site and assisted the bride and her attendants as they dressed for the ceremony.

Thalheimer's millinery department offered the newest styles in ladies' hats. In the early days, this section of the store probably did a booming business because women wore hats to meetings, church and even to the grocery store.

Once again, attentive clerks invited customers to sit in comfortable chairs while they offered hats in every style and color. Mirrors and effective lighting enhanced this upscale area.

The hair salon had a thriving business, as well. Trained beauticians gave cold waves, haircuts, manicures and occasionally scalp treatments to customers who had "shopped until they almost dropped." Ladies enjoyed the luxury of professional pampering without leaving the building.

One big plus concerning the Thalheimer's Winston-Salem store was the spacious parking lot behind the building. Just a punch of a ticket ensured free parking for as long as a customer needed it. What more could any serious shopper want?

Historic Bethabara Park

This area was an eighteenth-century Carolina Piedmont backcountry first inhabited by wild animals, Indians and outlaws. Then German-speaking Moravians settled here between 1752 and 1820 and established their homes, in which they could worship together, plant their medical gardens, educate their children, practice their customs, engage in various forms of the arts and establish trade.

Bethabara, one of the first Anglo-American settlements in this area, grew into a successful commercial center. During the French and Indian War, it became a safe haven for settlers. The Moravians built a fence around the middle of the town, which served as a defensive barrier. They also constructed a mill.

Today, the 175-acre 1753 site includes a reconstructed 1762 cabin, vegetable and medical gardens, a 1756 French and Indian War fort and a 1765 barn. Nature trails, wildlife and over one hundred species of birds abound in the wooded area. Flora and fauna resemble the wilderness of the frontier settlement.

The Bethabara Park Museum displays handcrafted Moravian gifts, colonial and natural history items and archaeological foundations—the sites of the Bethabara Mill, village and fort complex, plus two colonial graveyards.

Chinqua Penn Plantation

Near Reidsville in Rockingham County, about twenty-five miles north of Greensboro, Jeff and Betsy Penn built an English country mansion in the 1920s. They named the plantation Chinqua Penn. The word "Chinqu"

was derived from the word "chinquapin," which was actually a dwarf chestnut tree. The chestnut blight in the 1930s destroyed most of the area's chinquapins. The "Penn" part comes, of course, from their last name.

Many of the early plantation owners in the Piedmont Triad owned slaves, but slavery had been abolished in America before the Penns were born. "Plantation," in this case, refers to a large estate, including a magnificent house.

Since Jeff and Betsy Penn traveled a great deal, they bought furnishings, art and artifacts from their world tours. A replica of King Tut's chair, a Chinese pagoda and Spanish artworks fill the house.

After Jeff died in 1946, Betsy became involved in charity events, including the Reidsville Community Chest, funding for the hospital and establishing a 4-H Center. Her generosity extended to the plantation workers and their children, for whom she purchased Christmas gifts every year in New York City.

Betsy died in 1965. Her former chauffeur of fifteen years, Bob Boyles, remembered her as a polite and dignified lady. "I never once opened a car door for Mrs. Penn that she didn't thank me," he said. "I lost a real friend when she died."

Today, Chinqu Penn Plantation is a fine, well-preserved twentieth-century home. The plantation was given to the University of North Carolina system and then in August 2006 sold to Calvin Phelps, who operates the mansion and gardens as a museum.

Jamestown's Phantom Hitchhiker Bridge

While many people concentrated on post–World War I news in 1923, paranormal incidents occurred in Jamestown that escaped local and regional newspapers. Only through various oral histories do North Carolinians know about Lydia's Bridge.

Lydia's appearance began about a year after her death in 1923. The story goes something like this: a young woman wearing a white evening dress stands next to the underpass on Route 70 east of Jamestown, near High Point. She signals for a driver to stop and requests that he (always a male) take her to her home in High Point because she and her date had a terrible argument while at a dance.

The driver agrees to deliver her safely to her home. According to Piedmont Triad legend, Lydia gives him precise directions, and when they arrive at their destination, the driver goes to the passenger side to open the door for the girl in white. She's not there. Puzzled, he goes to the door of Lydia's house and knocks on the door. Lydia's mother answers, he tells her what

Left: The bridge spanning Deep River, Jamestown. *Library of Congress.*

Below: One-hundred-tale ghost story gathering. *Library of Congress.*

has happened and she then informs him that her daughter was killed on the night of the dance. She shows him a picture of the young girl.

Today, three different bridges in the area are called "Lydia's Bridge." One is also known as Graffiti Bridge. Another crosses a creek, and kids have spray painted pentagrams on it. The original Lydia's Bridge, however, is now covered with kudzu.

Occasional reports tell of male drivers who still see the shadow of a young woman. They hear screams. Knowing the story of Lydia, they wonder if their minds are playing tricks. Are they seeing light images and not a young woman? Are the screams merely echoes of children playing outside at nearby apartment complexes? They wonder.

Interestingly, Lydia Jane M. (last name withheld) did exist. A Guilford County/High Point death certificate states: "Born 1904 in High Point and died December 31, 1923, from fatal injuries from a motoring accident…"

Some curious people in search of Lydia still walk through the thicket that brings them to the old bridge and enjoy telling ghost stories about Lydia's appearances. Lately, she has not been seen.

Uncle Ivey's Garage

From about 1900 until 1939, automotive histories focused on Henry Ford's Model T, but popular culture concentrates on how early automobiles affected society. Of course, the car represented modern technology and, according to one book review, "became the technological means to solve cultural and social problems."

The invention of the automobile freed families to live in rural areas that had roads. Opposite horse-drawn travel at approximately twelve miles per hour, the car could move faster. In addition, farmers could now quickly deliver perishable produce to market.

For people in the Piedmont Triad—as in every area—cars became status symbols to differentiate between owners and those without, and the newer the vehicle, the higher one climbed the social ladder.

Cars, of course, needed repairs, so what we know today as "shade-tree mechanics" came up with innovations, including heaters, gauges, starters, luggage boxes and signals. Interestingly, female drivers could repair car bodies and engines as well as their male counterparts. Women enjoyed magazines and serial novels such as *Automobile Girls*. They very quickly became the victim of jokes about female drivers, so they ultimately took their places in the passenger seats.

As time went by, the "shade-tree mechanics" turned tinkering over to repair shop mechanics, and these shops prospered. One such business was Ivey Briggs Service Station and Garage, three miles east of Lexington on Highway 64, a main artery that ran from Manteo on the coast to Murphy in the mountains and extended through Tennessee as it wound its way to the west.

Briggs Service Station was a typical filling station—square with a canopy. Two hand-operated gas pumps sat between the columns that supported the canopy.

Next to the station stood a large wooden whitewashed building with a tin roof—Briggs Garage. One side contained a tractor repair shop and the other a car repair body and welding shop.

A paving invention, burnt motor oil and drink caps, prevented the parking area from getting muddy when it rained.

A 1919 Essex in a garage repair shop.

This business served the surrounding communities of Beck's Church, Hedrick's Grove, Silver Valley and Holly Grove. It was operated by Ivey Briggs—fondly referred to as "Uncle Ivey" by everyone—his son, Arlin, and Pete Kepley, the tractor mechanic. Uncle Ivey always wore bib overalls and a hat similar to a policeman's but with an Esso emblem on the front. Arlin's outfit consisted of striped coveralls with Esso on the pocket. Pete wore gray coveralls and a railroad cap. The only time they dressed differently was on Sundays, when they wore suits and ties to church.

Most of the men in the surrounding communities worked in Lexington at the furniture plants, textile mills or Coble Dairy. Many of them farmed on the side. They would stop by Uncle Ivey's on the way to work or on the way home. The big day of meeting and fellowship was Saturday. One group would sit outside and lean back in wooden chairs or sit on ale crates and shoot the breeze. As they watched passersby, they commented on everybody. Others went inside, sat around a potbellied stove and talked against a backdrop of mounted deer heads, bear heads and a largemouth bass.

Some played checkers or setback, and once in a while they might utter a "darn it," a "dog-gone" or an occasional "damn." Anything stronger and they were asked to leave. They knew better than to use profanity in front of the few women and children who stopped by the service station.

Arlin was a master mechanic, welder and paint and body man. Self-taught, he was good at what he did. He also drove a wrecker and pulled in cars and tractors that needed repair. Pete worked strictly on tractors. He arrived in the morning at seven, ate lunch at eleven and went home at five *sharp*, six days a week. No exceptions!

Places

Uncle Ivey stocked a few groceries such as loaf bread, dinner rolls cornmeal, etc. He also carried mayonnaise, vinegar, salt, pepper and other essentials. He sold a lot of drinks, candy and ice cream cups, Eskimo Pies and Fudgsicles. His drinks were found in a big box provided by Coca-Cola. He stocked Coca-Cola, Pepsi, RC Cola, Seven-Up and Orange Crush in a brown bottle. The cooler box consisted of water circulating over the bottles, so drinks were cool but not cold. Sometimes men would have to wipe rust from the tops of the bottles before they drank. Other items for sale included cigarettes, cigars, chewing tobacco, snuff and pipe tobacco. The store provided brass spittoons for the chewers and spitters. Some of the patrons would open the door on the potbellied stove and spit inside. The spittle would make a frying sound when it hit the fire. Other items inside included spark plugs, fan belts, flashlights and batteries.

Outside, motor oil was sold in glass jars with a pouring spout. To get gas, Ivey first had to pump it out of the ground into a glass cylinder on top of the gas tank. The cylinder was divided into gallon measurements, starting at one and going to ten. He pumped the amount the customer wanted into the cylinder and stopped when he reached the desired gallons. Then he removed the hose and inserted it into his customer's car. Gravity emptied the gas into the tank.

Uncle Ivey fixed a lot of flat tires. All tires back then had tubes inside. When motorists hit a nail or sharp rock, the tire would go flat immediately. To find the hole and patch it, Uncle Ivey would have to remove the tube, put it in a big water tank to inflate it and hold it under water to find the hole. The water would bubble and show him where he needed to patch. Some of the tires had been patched as many as ten or fifteen times.

One last story about Uncle Ivey. A little boy lived in the neighborhood. His father, a railway postal clerk, left on rail trips every other Monday and didn't return until Saturday or Sunday. When he was gone, this little boy walked down to Uncle Ivey's store. He wanted one of three things: a Pepsi (because it was twice as big as a Coke), an Eskimo Pie or a Fudgsicle. He had a unique way of paying. After opening the drink and taking a swallow or biting from the ice cream, he paid Uncle Ivey with a button.

Uncle Ivey would smile, thank him and send him on his way. Then he would make a note and stick it on a wall nail. When the little boy's dad returned home, he settled up with Uncle Ivey.

Those days have come and gone forever, never to be enjoyed again. Some people say there is no such thing as the "good ole days." There are those old-timers who would reply, "I beg to differ."

CONVICTED MURDERERS AND OTHERS WHO WENT FREE

Blanche Taylor Moore

Blanche Taylor Moore currently serves a death penalty sentence in North Carolina's Raleigh penitentiary. On July 18, 1989, Moore, nicknamed the "black widow," was charged with the first-degree murder of her boyfriend, Raymond Reid. She had slowly, but deliberately, poisoned him with arsenic. Before Reid died, Moore had talked him into signing his net worth over to her.

Blanche Taylor Moore then assumed the persona of a wholesome but grieving woman. She enlisted Reverend Dwight Moore, a local United Congregational Church minister, for comfort. Four years later, they married, and his bank account also became hers. One of their first meals as husband and wife included waffles, bacon and arsenic. Moore became ill, recovered, regressed and recovered again. Doctors and routine tests provided no real reason for his illness. Finally, toxic tests proved that Moore had ingested arsenic—a great deal of the poison—in banana pudding that Moore made and spoon-fed him while he lay in the hospital. Reverend Moore lived through the ordeal.

The bodies of boyfriend Raymond Reid and also Moore's first husband, James Taylor, were exhumed. Those men had died of lethal doses of arsenic poisoning; however, they were not the first. Moore had poisoned her father, Parker Kiser. She had doctored his beer stein with enough arsenic to kill him. These almost unbelievable circumstances probably remain etched in the minds and hearts of many.

It's only natural to ask, "Why?" Various sources reveal possible reasons for Moore's actions in poisoning those whom she supposedly loved. Her traveling preacher father sold her into prostitution when she was a teenager. This was how he satisfied his many gambling debts and also got money to buy the liquor he craved during the Depression era. Then Jim Taylor, Blanche's

Here children sit on steps on an unknown street; note the beer sign in the window. *Library of Congress.*

first husband, escaped nightly to local taverns to drink the evenings away. When Raymond Reid's intention to marry Blanche waned, he, too, died of a mysterious ailment.

Jim Schutze, an investigative newspaper reporter, relates in his book *Preacher's Girl* that Moore is a "perfect psychopath—totally camouflaged, completely accepted, utterly amoral." Schutze interviewed hundreds of people who knew Blanche and became players in her sad and violent history: "Her father selling her body to pay his gambling debts, Blanche's twisted fascination with Jesus and oral sex, and her deadly inability to accept the shortcomings of the men in her life who loved her."

Libby Holman and Ab Walker

A torch singer in the 1920s and '30s, Libby Holman married millionaire and tobacco heir Zachary Smith Reynolds in 1931. Libby was twenty-seven and Smith only twenty. They moved from New York to the Reynoldses' Winston-Salem estate, where they spent their days and nights lavishly entertaining

young friends. On July 4, 1932, at an alcohol-fueled party, Libby told Smith that she was pregnant. After they argued, guests heard a gunshot. Smith had apparently shot himself. Local and regional newspapers reported these facts. In fact, the tragic event received much the same publicity as did the Charles Lindbergh baby kidnapping and the O.J. Simpson case.

Headlines and newspaper accounts overshadowed some of the events that have surfaced in articles and published books since Smith's death. Published accounts indicate that Libby was bisexual, preferring the company of both gay men and lesbians, including the DuPont heiress Louisa d'Andelot Carpenter Jenny and writer Jane Auer Bowles. She also enjoyed a relationship with actor Montgomery Clift.

"Moanin' Low" and "Body and Soul" became two of her earliest hit songs. Audiences admired her figure, her wardrobe of elaborate, strapless evening gowns and her smoky, sexy voice.

Smith Reynolds, a young playboy who displayed little interest in the family tobacco business, exhibited a fiery temper and spent his days flying his own plane. He became enamored of Libby and persuaded her to marry him. Soon after their wedding, Smith insisted that she leave Broadway, and regretfully she obeyed. She consented to live for one year at the Reynolds' home in Winston-Salem. Soon after their arrival in North Carolina, Libby began inviting her theatrical friends to Reynolda, where their personalities clashed with the elitist family.

Ab Walker—an old friend of Smith's and reported lover of Libby's—and Libby were both indicted for Smith's murder; however, his death was eventually ruled a suicide. Libby returned to New York, and with her inheritance she bought a Manhattan town house and a sixteen-bedroom mansion on fifty-five acres in Connecticut. Six months after her husband's death, Libby gave birth to a premature son whom she named Christopher and called "Topper." At the age of sixty-seven, Libby Holman committed suicide on June 18, 1971.

John Andrew Roman

John Andrew Roman was convicted of the August 1951 murder of Beulah Miller Hinshaw. Sixty-five-year-old Hinshaw lived alone at 950 South Main Street in Lexington. Her husband, H.W. Hinshaw, who had operated a fruit and produce business and was a city firefighter, had died eleven years earlier.

About 8:30 p.m. on Sunday, August 12, 1951, Roman left the ice plant where he worked and went to Hinshaw's house, according to newspaper accounts.

He cut a back screen door to gain entrance into the house, and he struggled with the woman, who then apparently ran out into the backyard. Roman stabbed and raped her and returned to the ice plant about 11:30 p.m.

Hinshaw's body was discovered the next morning by her sister and a neighbor, who became concerned when Hinshaw failed to meet them for their weekly Monday morning clothes-washing chores.

Lexington police officers picked up Roman for questioning shortly after noon on Monday and charged him after they found a pistol and two watches that belonged to Hinshaw in a building across the street from the ice plant.

Roman, a World War II veteran and the father of four children, denied knowing anything about the case. He maintained his innocence to his death.

Roman's trial started on Monday, January 28, 1952, in Davidson County Superior Court. Roman, who was black, was represented by two black lawyers from Winston-Salem, Hosea Price and Harold Epps. Charles Hagan, the solicitor for Davidson County, represented the state.

Price presented a motion to have the grand jury indictment for first-degree murder dismissed. He claimed that blacks had been deliberately excluded from the grand jury, but Judge Will Pless Jr. denied the motion and noted that three of the eighteen members of the grand jury were black. Forty-eight potential jurors, including fifteen blacks, were brought in from Guilford County in accordance with a motion made by Price. Four black jurors were seated on the jury Tuesday.

The state presented its evidence throughout Wednesday. In addition to items found in the building across from the ice plant, Solicitor Hagan also presented several pieces of circumstantial evidence linking Roman to the death of Hinshaw, who was white. Fingerprints found on a metal box in Hinshaw's house matched Roman's. Hairs on a rubber boot found in Hinshaw's yard matched hair samples from the woman's leg.

The state rested its case Thursday, and the defense presented no evidence. Price said that Roman's attorneys, Price and Epps, were counting on the jurors not convicting Roman based on circumstantial evidence. Jurors deliberated until 9:00 p.m. Thursday and returned a guilty verdict on Friday. Law required Roman be sentenced to death, and an execution date was set for March 21, 1952, in the state penitentiary in Raleigh.

Parks noted that the case was the first time in Davidson County a man had been convicted solely on circumstantial evidence.

Roman appealed his conviction to the state Supreme Court, but the appeal was denied. He was asphyxiated with cyanide gas on Friday, June 6, 1952.

Old Davidson County Courthouse with the monument of the Confederate soldier facing north, watching and waiting for a Yankee approach.

Rob Coulthard

People in the Piedmont Triad who knew Sandy Coulthard considered her life almost perfect. She and her husband, Rob, both Wake Forest University graduates, lived the good life. They had two healthy children, Rob held a great job as manager at a furniture manufacturing company in High Point and Sandy, the daughter of a prominent family, enjoyed her charitable work in the local Junior League.

When thirty-year-old Sandy became extremely ill in July 1988, shortly after giving birth to her second child, doctors diagnosed her symptoms—numbness in her limbs and severe nausea—as Guillain-Barré Syndrome. Only after her death at Duke University Medical Center, burial and exhumation did toxicologists confirm that Sandy died of massive doses of arsenic. Rob had poisoned her five times over seven months, administering the final fatal dose as he fed her ice chips at Duke.

What would make a seemingly loving husband kill his wife? Some experts call Coulthard an "organized psychopath" who meticulously charted his plan. He had ordered the arsenic in 1986 and paid for the poison with a check for $196.49. His first mistake was having the package shipped to his office, where a co-worker noticed a skull and crossbones on the box and

teased Rob about his planning to kill Sandy. Rob countered with a lie: he had a rat problem at home. Only after Rob changed jobs two years later did he continue his well-thought-out plan. First, he took out life insurance policies on Sandy's life to the tune of $351,000. He named their two children as beneficiaries, a planned act that ultimately allowed Coulthard to escape the death penalty.

According to some experts, naming the children as beneficiaries prevented the murder to be tried as a capital case because Rob could not be accused of profiting from Sandy's murder. Coulthard pled guilty to first-degree murder, thus escaping a trial, avoiding execution and securing possible parole within twenty years.

Some insisted that Coulthard's naming his children as beneficiaries indicated his desire to escape remaining family responsibilities and subsequently place his children with Sandy's parents. Others speculate that Coulthard wanted to be a "high roller, good looking, and available guy." In fact, at one time, he was so in debt and addicted to gambling that he placed a bet with his bookie from his church.

Family members and friends of Sandy wondered, of course, why she remained so unaware of her husband's addiction to gambling and his involvement with a mistress (whom he called from a Duke pay phone after he had fed Sandy her fatal dose of arsenic and watched her die). Sandy had recently given birth to their second child and was trying to regain her health after several arsenic poisonings. In addition, Coulthard has been called a talented actor who could easily extol himself and persuade others to trust him, including Sandy.

An interesting but sad aside concerns the judge who presided over the case. He feared for his life after receiving death threats as a result of the plea.

Michael Hayes

When people in the Piedmont Triad hear the name Michael Charles Hayes, they probably remember a horrible July 17, 1988 Sunday night killing spree along Old Salisbury Road. Hayes, apprehended by deputies called to the crime scene, has been hospitalized at Dorothea Dix State Mental Hospital in Raleigh since his trial ended.

Few folks are privy to the chain of events preceding the shootings. Ronald Lee Hull, thirty-two, and his wife, Darlene, twenty-nine—wounded but survivors—pieced together the events of their evening. They had been at

a family celebration with their son, Ronald Adam Hull, eight. They had grilled outside and intended to fish; however, the July heat had forced them inside, where they played penny ante poker and bingo

After the Hulls left the gathering, they started home in their truck, driving along Old Salisbury Road. Someone in the road waved the vehicle to a stop. The second that Hull applied brakes, the assailant, Michael Hayes, smashed the driver's window. Hull tried to reason with him, but before he could get out of the truck, Hayes put a gun to Hull's head and pulled the trigger. When Darlene started screaming, Hayes shot her, but not before she yelled for their son to get on the floorboard.

Next, Michael Hayes shot Melinda Yvonne Hayes (no relation), age twenty-one, as she returned from driving her boyfriend to his house on Jonestown Road. Ms. Hayes worked at Shutt Hartman Construction Company in Clemmons, and she and her boyfriend had plans to marry. Her brother, called by deputies, arrived at the scene to find the driver's side of his sister's car filled with blood.

Then, Crystal Suzanne Cantrell, sixteen, had visited Sunday with her boyfriend, Jonathan Annas. Crystal had just received news that she had been named to an all-star softball team to represent North Carolina in interstate competition. She would play as pitcher and infielder with practices to begin in King the next day. In addition, as a rising senior at Parkland High School, she actively participated in the Dixie Debs dance team and the Latin Club. Crystal left Jonathan's home in time to meet her 11:30 p.m. curfew. Michael Hayes stopped her black Camaro and killed her.

Thomas Walter Nicholson, twenty-four, had visited his fiancée, Bobbie Jo Eddleman, in Yadkin County this particular Sunday night. In his old Dodge pickup, he headed home to his parents' house. Tom, a machinist and engine assembler at Golden Shamrock Enterprises on Old Salisbury Road, had graduated from Davie High School, where he was voted president of the student council. Tom had wholesome interests; his friends later said that he was the last person they would imagine would be shot and killed. Tragedy struck in the form of Michael Hayes standing on the centerline of a darkened road in front of his parents' moped shop.

Hayes, believed to have begun drug use at age thirteen, exhibited unacceptable social behavior. He later said that he believed all the people he shot were demons who needed to be killed. Hayes ultimately received a not guilty (by reason of insanity) verdict and was sent to Dorothea Dix State Mental Hospital. After taking a drug called Haldol, used to treat aggression and schizophrenia, Hayes was taken off the medicine in 1989. Dix Hospital psychiatrists allowed him to leave the hospital to work at a Raleigh gas station,

but his employment was short-lived when the owner received anonymous threats to firebomb the store or to kill Hayes.

Hayes's release from Dix was again denied on September 27, 2007.

Lawson Family Murders

On Christmas Day 1929, Charlie Lawson of Stokes County murdered his wife and six of his seven children, an event known in the Triad Piedmont as one of the most horrible and mysterious mass murders in North Carolina history.

On this snowy day, Lawson shot his wife, Frannie, and shot or bludgeoned with the butt of his rifle his children—Marie, seventeen; Carrie, twelve; Mae Bell, seven; James, four; Raymond, two; and Mary Lou, four and a half months old. Then Charlie Lawson escaped to the woods. He killed himself several hours later.

Most natives of Stokes County have heard of this tragedy many times, but not everyone in the Piedmont Triad knows of the revealing circumstances

A Lawson family portrait taken on their trip to Winston-Salem a short time before the murders. *Trudy Jones Smith*.

preceding the mass murders. The saga, as reported by family members and neighbors, actually began in August 1929 when Frannie gave birth to baby Mary Lou in a Winston-Salem hospital. While Frannie spent a week in the medical facility recuperating from childbirth, oldest daughter Marie assumed the household responsibilities and care of the children.

Sources indicate that a few weeks before Christmas, Frannie Lawson confided to her closest kin the serious problems in her home. She said the day she returned home from the hospital with their infant daughter, Charlie told Frannie he had something he had to tell her but that he didn't know how. When Frannie begged him to reveal his troubles, Charlie abruptly changed his mind, said he would tell her at another time and thanked her for being such an understanding wife.

One woman, who insisted that she remain anonymous, confided to Bruce Jones, author of the book *White Christmas, Bloody Christmas*, that she could provide some answers to the mystery surrounding the killings. She said that Charlie Lawson had impregnated his daughter Marie and warned her that if she told anyone—including her mother—there would be dire consequences. However, as Marie neared her fourth month, Frannie sensed Marie's pregnancy and insisted that she name the father of the baby. Marie complied, revealing that her father had impregnated her.

Of course, no one will know for certain what caused Charlie Lawson to murder his wife and six of his seven children (the oldest son, Arthur, had walked in the six-inch snow to a Germantown store to buy shells for the Lawson males' traditional Christmas Day rabbit hunt). Mysteries remain, even to this day; however, after many years, family members have come forward and helped fill in some of the gaps. Some speculate that an earlier head injury caused Charlie to go insane; others say that perhaps a growth on his chest could have been malignant. No one knows, but all agreed he definitely had an erratic personality.

M. Bruce Jones, deceased Stokes County native, researched Charlie's motive for the murders for years. In 1990, he revealed some secrets surrounding the murders. According to verified reports, one of the neighbors on the farm that Christmas morning engaged in target practice with the Lawson boys. When Charlie sent nineteen-year-old Arthur to Germantown for more shells, this particular young man started out with Arthur, walking the railroad tracks. Then he changed his mind and decided to wait at the farmhouse, even though he knew that Charlie Lawson hated him. Jones admitted that he knew the identity of the young neighborhood boy, but (in 1990) he respected his advanced age and poor health and decided to honor his desire of more than sixty years to remain anonymous.

First, Charlie killed Carrie and Mae Bell outside. After he shot them, he then administered blows to their heads with a three-foot, two-by-four plank that he had found against the side of the tobacco barn. Next, Charlie started toward the farmhouse.

Frannie had gone on the porch to gather more firewood. Charlie's deafening shot ripped a huge hole in her body. Marie and the young neighbor looked out the front window. Marie screamed, and in fear for his own life, the young man fled. Charlie stepped over Frannie's body, entered the farmhouse and started toward Marie. Young James and Raymond hid.

Charlie picked up his shotgun and shot Marie with such force that it snapped her neck. The mantel clock, hit by that pellet, stopped. It was 1:25 p.m.

After scrambling around, Charlie found little James and Raymond and killed both of them. He bludgeoned the baby, Mary Lou, as she lay in her crib. Charlie then ran into the woods, where he wandered for hours before taking his own life.

What actually happened? Rumors and speculation flew until one of the Lawson family members, Stella Boles, came forward. Knowing for sixty years what truly happened had burdened her mind and soul. She felt that it was time to reveal what she knew as the truth. On December 27, 1929, after the funeral, some of the ladies of the extended Lawton family gathered to console one another. Stella, only a child, joined their group. She learned from her Aunt Nina and the other women that Marie was, indeed, pregnant with her father's child. Frannie had suspected an abnormal relationship between Charlie and Marie for more than a year. Frannie was angry and scared of her husband, who had become more disturbed and violent since Marie said that she was marrying her true love, Charlie Wade Hampson.

Stella's Aunt Nina had sworn her niece to secrecy, saying that the scandal should remain in the family because the mass murders were more than enough to endure. Stella finally realized that the secret had forced her to lie for a long, long time. She came forth with the truth and possibly solved the mystery of the Lawson murders so many years ago.

FORGOTTEN TALES FROM THE HALLS OF HIGHER LEARNING

High Point College: The Early Years (1924–1927)

When asked in a personal interview one summer morning in 1987 how he got tagged "first graduate of High Point College," Herman E. Coble leaned back in his chair, thought a moment and then told the story of his association with the college:

> *Well, I came to High Point College, which was in the process of being built, during the summer of '24, and I became a laborer in and around the buildings, which were to open their doors for the first time in the fall.*
>
> *I had started out at Wake Forest because High Point College wasn't finished, but I transferred as a sophomore and graduated with the first class in 1927. There were only thirteen of us. Dean Lindley wanted me to introduce the speaker. Because I was already on the platform, I got the first diploma. I remember Mae Frazier was valedictorian, and she was the second person to receive a diploma.*

Lelia, Herman's wife of over fifty years, began talking about their college romance, their "courting days" as she called them. Before Lelia had a chance to finish, Herman interrupted, "They *did* let us wave at each other," he explained.

Lelia giggled and added, "Miss Mary Young, our dean, was a *very* respectable woman. We got to court fifteen minutes on Sunday in the Club Room of Woman's Dorm. I can hear Miss Mary now," Lelia reminisced, her eyes sparkling. "'Now *don't* hold hands with a boy.' But Herman was Miss Mary's favorite, so she sent us out to find other couples. You see, we had Honor Dates on Saturday and Sunday, and if a couple went uptown and didn't get back in time, Herman and I went to find them."

"They did let us wave," Herman repeated, looking at the ceiling and chuckling as if recalling some well-kept secret.

Above: Masons ready for the cornerstone ceremony at High Point College, November 14, 1924.

Right: Herman Coble, with hat, High Point College, 1924.

McCulloch Dorm, High Point College,
1924. "My window that's raised."
Herman Coble.

Early days at High Point College:
Herman Coble at McCulloch Dorm.

Forgotten Tales from the Halls of Higher Learning

We do tend to forget those devilish pranks we played as young men and women. In its infancy, High Point College had its share of mischievous college kids.

The High Point College auditorium, located on the south end of the second floor of Roberts Hall, was the scene of the prank. Picture rows of straight-back chairs in front of a stage, where faculty members sat facing their students during chapel—a dignified and solemn religious event. Usually. Some of the young college men had borrowed a cow from Mr. Dalton's farm across the street, coaxed her up the steps into the auditorium and left her there long enough for the animal to wander and mess—and then mess a great deal more. Now picture dignified Dr. Andrews, president of the college, proudly leading faculty and students to morning worship. Imagine his expression as the cow greeted him with a loud "moo."

According to Mr. N.P. Yarborough, dean of men at the time, "Dr. Andrews was purple with anger. He dismissed the girls and questioned all the boys, who were told to stay."

Louise Adams, a student, says that the entire incident was over—for the girls—as soon as Dr. Andrews saw the disorder, and she probably would have missed the entire thing except "somebody shoved me in the auditorium, so I got to see the cow."

Officer Hal of campus security arrived on the scene, and he organized an official rescue to remove the cow from the auditorium. Student Elwood Carroll experienced a great deal of difficulty leading her from the stage, through the auditorium, back down the stairs and to the Dalton farm across the street.

Apparently, a cow can be led up steps without too much trouble, but getting one to go down is another matter. Louise Adams recalls, "The cow was pregnant, and getting her to go downstairs was too much for her. We heard she died."

Herman Coble declared that he had no involvement in getting the cow into the auditorium. "But I did help get her out and back to her owner. We had to tie a sack across her head to get her down and back across the road…had to blindfold her…I guess the whole thing was too much for her. She was with calf, and she died."

Herman said matter-of-factly, "Mr. Dalton sued the college. Pretty steep price he asked. The cow was with calf, and the man made claim for both. The college paid up."

Another adventure proves again that students at High Point College (1924–27) were less than angelic. Mr. N.P. Yarborough recalled one particular night:

McCulloch Dorm, where dean of men, N.P. Yarborough, resided in 1924.

It was about one o'clock. I was awakened by the tower bell—a slow toll. I was living in McCulloch as dean of men at the time, so I went over to Roberts Hall, went up the tower stairs with my hands over my head to keep from being sand bagged. But the tower was empty. So, I went back to my room in McCulloch just in time to hear the bell again. Going back to the tower, I found a cord tied to the bell clapper and leading to the sweet gum tree near the campus entrance. I went back outside and began to haul in the cord. Three boys jumped out of the tree. Two of them ran to the street, but I caught Swampy Hearn.

Night antics were apparently the most fun. Young men on campus had a fondness for dismantling Model Ts and transplanting various parts to the least appropriate places. One night they distributed them in a gully near the Wrenn Building. Another time they displayed an engine, steering wheel and other Model T parts in the Roberts Hall Faculty Sitting Room. According to N.P. Yarborough, "Cylinder oil was permanently sealed in the rug of our Sitting Room; we never got it all out."

The coeds were a little more subdued, even in their meanest moments. According to Louise Adams, "All the dressers were alike in all the women's rooms. We entertained ourselves by exchanging one dresser drawer in a room for a similar dresser drawer in another."

Louise quickly added, "I went to boarding school before arriving at High Point College, so I knew all the tricks of dorm life."

Although students were allowed a long weekend away—they had to have written permission to go home—Louise figured out a way to get to

FIRST ANNUAL BANQUET

GIVEN BY

THE JUNIOR CLASS
OF HIGH POINT COLLEGE

TO

THE SENIOR CLASS

WEDNESDAY EVENING, MAY 4, 1927

High Point College's
first annual banquet
program.

Wake Forest (the town and the college at this time) for the High Point/Wake football game. She reminisced:

> I had classes on Saturday, but I decided if I got permission to go to Greensboro and spend the night with my aunt, I could work out a way to get to Wake Forest. I went out to the street to catch the Carolina Trailways bus, and the football team and coach came long.
> "Louise, where are you going?" asked Coach Brown.
> "Greensboro."
> "Get in. You can ride with us."
> He was considered faculty, so I rode with him and the football team. Wake Forest won…but not by much.

Of course, to counteract the pranks and practical jokes, students became academic and serious during their classes, club meetings, recitations and banquets.

Salem College

In 1766, Sister Elisabeth Oesterlein, age seventeen, walked from Bethlehem, Pennsylvania, to Salem. She founded the Little Girls' School, the first of its kind to accept nonwhite students. In 1802, it became a boarding school and by 1866 had changed its name to Salem Female Academy. The name was changed to Salem Academy and College in 1907.

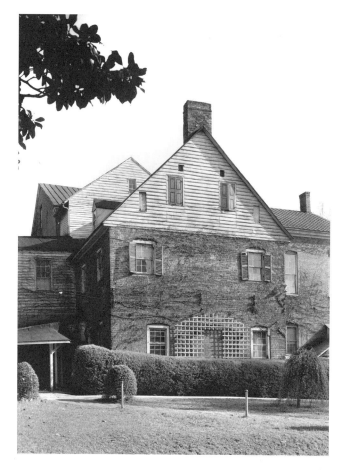

Old Chapel Annex, Salem College.

Constructed in 1785, the Single Sister's House—now the oldest building in the United States dedicated to women—had an addition constructed in 1819. Today, the fourth-floor attic of the Single Sister's House displays the original 1785 date stone and uncovered graffiti.

Forgotten tales abound surrounding Salem College. Clewell Dorm reportedly has the ghost of a young girl who fell down an elevator shaft. Strong Dorm has a spirit who uncovers young women while they sleep. Furthermore, a phantom in the Fine Arts Center walks the halls at night and plays the organs and pianos.

Long ago, a girl went to the third floor of Gramley Dorm, then an attic, and hanged herself. The young women today residing on the second floor can hear the girl's spirit dragging a trunk across the floor, marbles dropping on the ceiling, furniture being moved and knocking on open doors and can feel a female ghost's presence.

Salem Square, Salem College.

A portrait of Mary Reynolds Babcock, daughter of R.J. and Katharine Reynolds, hangs in the lobby of Babcock Dormitory. Students say that Mary's eyes follow them as they walk by. They often say "hi" and "bye" to the portrait.

In Gramley Library, students report seeing strange apparitions and hearing screams coming from the third floor. Supposedly, two girls died there in 1907 by electrocution.

State Normal and Industrial School/Woman's College/University of North Carolina Greensboro

A crusade headed by Charles Duncan McIver on behalf of the education of women was responsible for the State Normal Industrial School, which opened on October 5, 1892, in Greensboro, North Carolina, with a faculty of 15 and a student body of 223 young women. On this ten-acre site, college classes were categorized in three ways: business, domestic science and teaching. This was the first public institution in North Carolina for the higher education of white women.

In 1897, Katharine Smith and her State Normal and Industrial roommate, Emma Lewis Speight, decided to leave their dormitory room for a walk in the park near the campus. With heavy coats, caps, mufflers, gloves and snow boots, the two strolled and talked. Katharine confided in Emma about the marriage proposal that R.J. Reynolds had made on her tenth birthday.

Katharine spoke her next words as precisely and persuasively as she knew how. In fact, years later, Emma would repeat verbatim her friend's response. "We will marry," Katharine said, "and when we do, we shall go to Europe on our wedding trip. I shall bring home a wonderful work of art. And I shall buy a great estate and have a thousand cattle on a hill and flowers all around."

Katharine's predictions all came true.

The name of the institution of higher learning changed to the Woman's College. The first two African American students enrolled in the fall of 1956, thus changing the school from the education of white women to the education of all women.

Today, we know this same school as the University of North Carolina at Greensboro (UNCG).

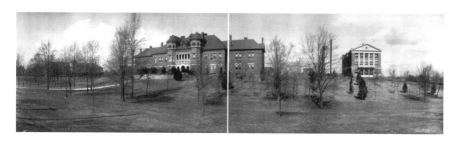

State Normal School. *Library of Congress.*

New Garden Boarding School/Guilford College

When Quaker settlers arrived at the place that they called "this majestic wilderness," the official name soon became New Garden, and John Woolman, a Quaker missionary, called them "planters of truth in the province."

Because these Quakers opposed slavery, many moved north by the 1830s; the remnant Quakers established a coeducational boarding school. Chartered in 1834 and opened in 1836, the name became New Garden Boarding School.

Unlike most educational institutions, New Garden Boarding School did not close its doors during the Civil War because the young Quaker men enrolled there refused to fight; furthermore, teachers and administrators resisted induction into the Confederate army.

After the Civil War, Quakers who had migrated north came back south to help former family members and friends rebuild their community. Another objective was to build schools for freed slaves and also teach them innovative farming skills.

The development of Guilford College, the fourth oldest degree-granting institution in North Carolina, evolved from this post–Civil War plan. For years the campus remained isolated until the old trail to Greensboro became Friendly Road.

The name changed in 1888 to Guilford College. In 1899, Guilford College is believed to have organized the state's first college basketball team. On February 6, 1906, Guilford defeated Wake Forest 26–19 in the first collegiate basketball game in the state. In 1953, the college established North Carolina's first adult education program.

In addition to these momentous firsts, Guilford's Hobbs House was supposedly the site of a devastating event. The Hobbs House used to be a real home, belonging to the Hobbs family. One night their daughter Mary entertained with a sleepover on the third floor. After the girls had gone to bed, some boys outside decided to play a trick on them. They wrapped rocks in paper, lit them and threw them into the room where the girls slept. The attic room caught on fire. Everyone escaped except Mary Hobbs. Rumor has it that if people sit in a specific room of the house, they can hear a girl scream amid the sound of faucets turning on and off and that they can detect footsteps in the hall.

Famous as home to the Eastern Music Festival and School, the Guilford College campus, amid a quiet, green area, provides summer concerts with instructive presentations by both students and professionals.

Committed to the values of community, diversity, equality, integrity, justice and stewardship, Guilford College has based these values on Quaker testimonies.

North Carolina A&T University

Today, most people know of A&T State University and the famous blue and gold "Aggie Pride." Few are in touch with the history surrounding this institution of higher learning.

Founded on March 9, 1891, and known as the Agricultural and Mechanical College for the Colored Race, the General Assembly of North Carolina ratified A&M as a "mechanical college." The act read, in part:

> *That the leading objective of the college shall be to teach practical agriculture and the mechanic arts and such learning as related thereto, not excluding academic and Classical instruction for African-American students at The Agricultural and Mechanical College for the Colored Race/NC A&T.*

At this time, of course, segregation laws prohibited whites and blacks from attending college together.

In 1893, citizens contributed $11,000 in cash and fourteen acres of land for its campus. Courses of study included languages and literature, mathematics, business, agriculture and military science. Female students attended from 1893 until 1901.

The name of the institution changed in 1915 and became the Agricultural and Technical College of North Carolina by act of the North Carolina General Assembly. Women were readmitted beginning in 1928, and in 1967 the college gained university status and was changed to North Carolina Agricultural and Technical State University. On the A&T seal are the words *mens et manus* (minds and hands), focusing on A&T's original interest in agriculture and technical skills.

Famous alumni include Reverend Jesse Jackson; Ronald McNair, astronaut and mission specialist who died in the space shuttle *Challenger* explosion in 1986; the A&T four Woolworth sit-in students; Clara L. Adams-Ender, retired brigadier general and first black Army Nurse Corps officer to graduate from the U.S. Army War College and first woman to earn a master's from U.S. Army Command & General Staff College; Lou Donaldson, jazz musician; and Sybil Lynch, '80s R&B singer.

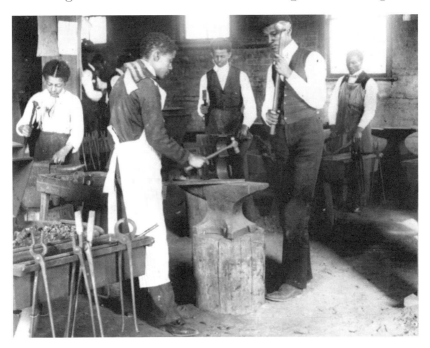

Blacksmithing at A&M College. *Library of Congress.*

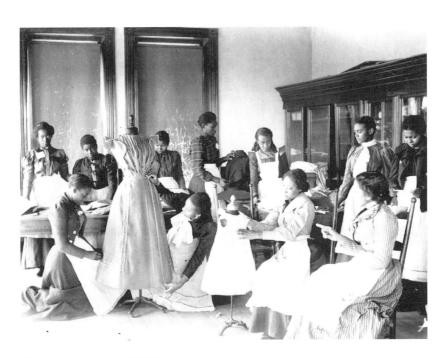

Cutting and fitting at A&M College. *Library of Congress.*

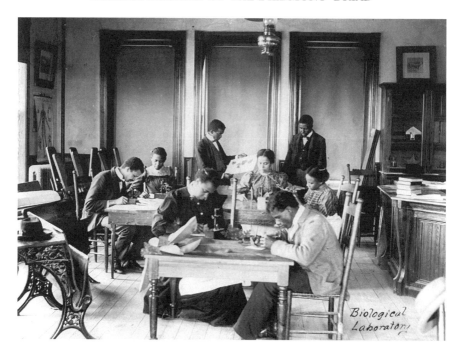

The biology lab at A&T College. *Library of Congress.*

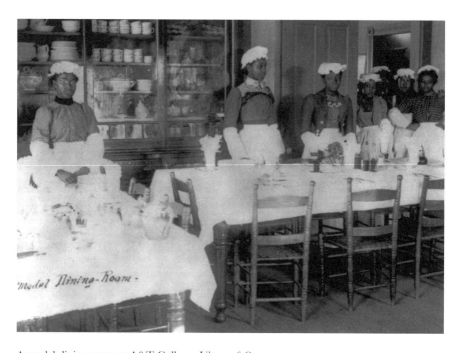

A model dining room at A&T College. *Library of Congress.*

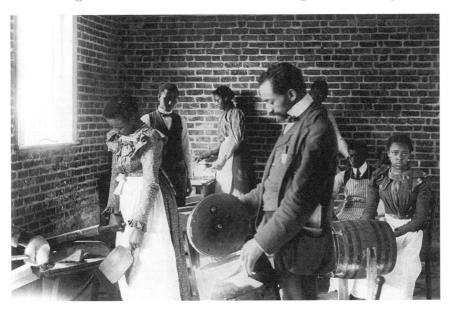

Butter making at A&T College. *Library of Congress.*

Greensboro College

Greensboro College is famous for many historical firsts. In 1832, Reverend Peter Doub, minister of First Methodist Church in Greensboro (now known as West Market Street United Methodist Church), opened the First Methodist Preparatory School for Greensboro's Methodist children. Espousing the philosophy that a good education was necessary for women as well as men, he then decided to provide a college for females and on April 15, 1846, classes began at Greensborough Female College, now Greensboro College. This was the first institution chartered as a college for women in North Carolina. The first students graduated in 1848.

On May 28, 1902, Lucy Robertson became president of Greensboro College, making her the first female college leader in North Carolina. Traditionally an all-female institution of higher learning, Greensboro College admitted its first male degree-seeking students in 1954.

Graduating the next year in the class of '55, Margaret Elizabeth McLarty, a music major and dramatics minor, made her professional debut in *The Lost Colony* in Manteo in 1956. Soap opera fans may not recognize the name Margaret Elizabeth McLarty, but they have likely followed Eileen Fulton through her CBS career as Lisa Miller on *As the World Turns*. Labeled the first

"bad girl" on soaps, audiences "loved to hate her." In fact, she became so popular on the daytime show that CBS featured her on a primetime soap, *Our Private World.*

Fulton starred in the first Broadway production of *Who's Afraid of Virginia Woolf?* and also had a lead part in the motion picture *Girl of the Night.* Since her graduation from Greensboro College, she has authored two autobiographies and six murder mysteries. In 1998, she was inducted into the Soap Opera Hall of Fame.

EVENTS

Burris Hospital's First Set of Triplets

Annie Montsinger Sullivan Davis, age thirty-three and an obviously pregnant woman, walked into Burris Hospital in High Point on Saturday night, August 27, 1938, with her thirty-six-year-old husband, Jesse Stanton Davis. No one, including the expectant parents, knew that she carried triplets because following the Depression, prenatal medical checkups were practically nonexistent in rural areas of the Piedmont Triad.

Family members remember Annie's lament during her uncomfortable pregnancy, "Oh, if I could just live to get this baby born." Although she had safely and uneventfully delivered two other children at their farmhouse in rural Kernersville, she knew that something about this pregnancy was very different. Perhaps she suspected multiple births because of her size and the fact that there were several sets of twins in her family. So, when her attending midwife felt that Annie needed professional medical attention, she asked Jesse to drive his wife over the long country dirt roads to Burris Memorial in High Point, the nearest town with medical facilities.

After Dr. W.R. McCain delivered the first baby, Sara, he said, "There's another one." After the second infant, Tom, arrived, Dr. McCain announced again, "There's another one." Then Martha, the smallest, entered this world. Sara and Tom weighed about five pounds each, and Martha weighed only four and a half pounds.

Annie Davis's private duty nurse later recalled, "I can remember Annie seeing the babies or her saying she saw them," she said. "But we didn't really know if she could see them. It was real sad, but it was not anybody's fault. They didn't have the drugs they do today to fight with. It was just a different world." Relatives have told Martha that she is more like her mother. "I talk all the time," she said. "I was the only one she held because I was weak, and

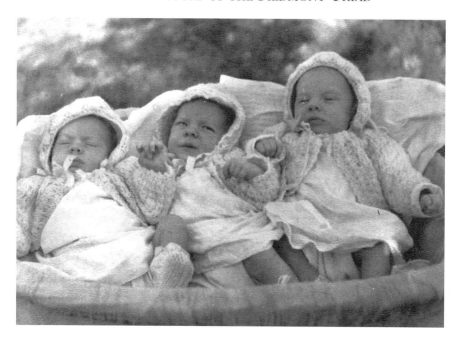

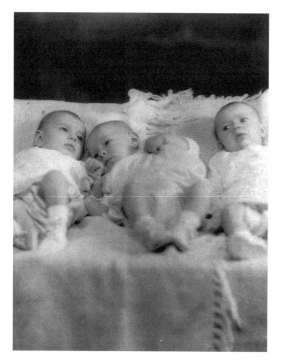

Above: The Davis triplets. *Courtesy of Martha D. Stafford.*

Left: The Davis triplets stayed with Mama Thornton for five and a half years. *Courtesy of Martha D. Stafford.*

they thought it might help me. But the nurses weren't sure she could see me because they thought she had gone blind at that time."

Annie Davis became extremely ill with uric poisoning and died of kidney failure five days after the multiple births. She was buried the next Saturday. "Jesse, we'll keep the babies as long as you want us to until you can find someone," hospital officials told Mr. Davis. The triplets' Aunt Edna asked Mrs. Evie Gosset Thornton if she would board the infants. Mama Thornton did not hesitate. She offered to keep all three for one dollar per day.

When Jesse Davis went to the hospital one day and asked about the condition of his children, a nurse said, "They're doing about as well as they'll ever do." Because Mr. Davis interpreted that to mean they might not survive in the hospital, he put all three in a wicker basket bassinet, left with them and drove to Mama Thorton's, about fifteen miles from High Point.

The triplets stayed with Mama Thornton for five and a half years. They went back to their father's house in time to enter first grade at Oak View School.

The Battle of Guilford Courthouse

The familiar cry "the British are coming" became an important part of North Carolina's history when Lord General Charles Cornwallis ordered his 1,900 redcoats into the small, remote Guilford Courthouse. While this name might suggest a building where legal trials are held and county business transacted, Guilford Courthouse was actually the name of a little town, today known as Greensboro, in north central North Carolina.

Usually home to about one hundred people, this backwoods county seat saw Major General Nathanael Greene gathering his 4,400 Patriots in the early morning hours of March 15, 1781. The battle that took place that day has gone down in history as a pivotal event in the Revolutionary War's southern campaign.

The farming community of Guilford Courthouse had experienced a long winter of both rain and snow, so on this early March morning the ground was still soggy. After the sun burned away a light frost, General Greene prepared his men and the professional soldiers he had brought from Great Britain and Germany for battle against Cornwallis.

General Greene knew that an effective strategy would be of utmost importance against the trained and disciplined redcoats. So Greene decided to use a plan that had worked months before at the Battle of Cowpens.

This plan consisted of organizing the Patriots into three lines. General Greene ordered all North Carolina militia to the first row and commanded

them, "Fire two volleys and then fall back to the second line." He continued, "Virginia militia, it will then be your turn to fire at the Red Coats." The final order was extremely important: "After you men on the second line fire, everyone must drop back to the third line where the trained soldiers of the Continental army will then fire the Grasshopper Guns, our four six-pound cannons."

All were in place when the redcoats began their advance across a field surrounded by fencing. From the partial safety of the woods, the North Carolina militia fired their two volleys, but instead of dropping back to the second row as they had been ordered, they were frightened and ran deeper into the woods. The British continued to advance across the field. The Virginians on the second row fired as ordered, killing many of the redcoats. Still the British soldiers came, fast and furious. Now it was time for the Continental soldiers to act. They fired the Grasshopper guns.

Cornwallis ordered his men to charge. This they did. He also ordered them to load the cannons with grapeshot and to fire anywhere and everywhere. Although many Americans and British were killed as a result of this decision, the Patriots halted their advance. General Greene wisely assessed the situation and commanded his soldiers to leave the battlefield. This they did, leaving the Grasshopper guns behind for Cornwallis's capture but saving many Patriots' lives.

The redcoats won the actual battle for the British, but the price was costly—93 men died on the field and 440 received wounds or were reported missing. The Patriots' tally indicated that 79 men died and 185 sustained wounds. In addition, those soldiers of the North Carolina militia who ran into the woods did not return.

After the battle, Cornwallis said, "Another such victory and we are done for." With so many men dead or wounded, he believed that another offensive attack would not be wise, so he retreated to Yorktown, Virginia, where eventually he was forced to surrender seven months later.

Woman's Christian Temperance Union Organization

North Carolina's first chapter of the Woman's Christian Temperance Union opened in Greensboro in 1883. We often think of this organization as one whose main goal concerns insisting on abstinence from alcohol. This, of course, is an important objective, but the WCTU's temperance reform included much more than stopping the sale of liquor in local saloons.

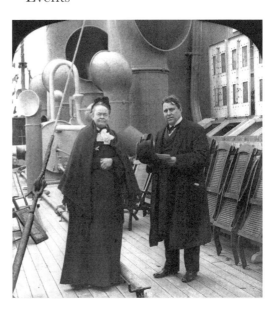

Carrie Nation with a WCTU member. *Library of Congress.*

The mission of the first WCTU organizations—including the Greensboro chapter, or "Union" as it was called—appeared to be broader. Their slogan "For God and Home and Native Land" more clearly expressed their crusades. One of their purposes, of course, was to eradicate alcoholic beverages, close saloons and nonviolently educate the public about the dangers of drinking.

According to several sources, this crusade was also a protest against current civil rights. At this time, women could not vote, own property or, if divorced, win custody of their children. Other issues prevailed: women and children received no legal protection, prosecutions for rape went unchecked and North Carolina's "age of consent" was as low as seven years old. In addition, temperance came to be defined in terms of not only alcohol, but also tobacco and drugs.

The WCTU eventually adopted the motto "Do Everything" meaning that all reform issues were connected, and problems should not—could not—be separated; by 1896 twenty-five departments of the organization dealt with more than temperance issues. Some of those reforms advocated shelters for abused women and children, equal pay for equal work, federal aid for education, prison reform, homes and education for wayward girls and passive demonstration to bring about world peace.

Today, the WCTU is the oldest voluntary women's organization in the world, and according to its leaders, women take pride in being able to "think on their feet," "speak in public" and "run an organization."

Carrie Nation. *Library of Congress.*

Dime Store Shopping

The old Piedmont Triad dime stores—also called five-and-dimes—usually appeared on the main street of a city, town or village. In Lexington, two five-and-dime stores faced each other across South Main Street. In both McClellans and Macks dime stores, townspeople could buy just about anything within those walls. Separate counters constituted what we would today call "departments," and a salesclerk presided at each, sold merchandise, collected the money, returned change and bagged the purchase. Of course, since everyone knew everyone else, there was a great deal of conversation about newcomers, industry, church life, clubs, parades and school functions.

Usually, toward the front and center of the dime store, a popcorn machine, with its buttery-salty aroma, invited everyone inside. Wooden counters with glass cases displayed yummy chocolate drops, peanut brittle, orange slices, candy corn and hot peanuts. After World War II, penny bubble gum reappeared in big bowls.

McClellans and Macks had different floor layouts, but usually men's and women's underwear, clothing and shoes were displayed on opposite sides of the stores. No dressing rooms were available to try on garments, but each department did have one chair and a footstool for anyone to try on a pair of shoes.

The 5 & 10 (cent) store. *Library of Congress.*

Household goods, such as pots and pans, baking sheets, biscuit cutters and measuring cups, lined the back wall. Next to those customers could find brooms, mops, pails, dish drains and light bulbs. Pet supplies and sometimes even live parakeets and goldfish also had a special corner toward the back.

The latest comic books, called funny books, earned a special spot near one of the front doors. Kids could look all they wanted without buying, but if someone had a dime, he or she could purchase an *Archie* comic and read and enjoy the antics of Archie Andrews, blonde Betty Cooper and brunette Veronica Lodge—depicted back then, as early as 1941, as cartoon teens with tiny button noses and five-inch-tall eyeballs.

Both McClellans and Macks had dress goods, lace, buttons, thread, rickrack, hem tape, scissors and a row of pattern books.

Costume jewelry and cosmetics had their own special counter. Rhinestone necklaces, bracelets and earbobs reigned regally on satin-padded displays. Tangee lipstick, Blue Waltz and Evening in Paris perfume beckoned to teen shoppers.

During the Christmas season, toys and dolls filled the front windows, letting children wish and dream about Santa's visit.

Jeanne Leonard recalls McClellans five-and-dime:

In McClellan's this domain was ruled with an iron hand by Mrs. Jimmie Phillips, a formidable woman, who for fifteen cents would hand you a whole bag of candy corn that had been carefully weighed in her balance scale. Those glass-fronted cabinets, the hot peanut display and the popcorn machine filled the whole store with a tantalizing aroma. As a teenager, I worked in the store and would sneak behind the counter when Ms. Jimmie wasn't looking to sample the chocolates, risking her feigned wrath.

Across the street at Macks, shoppers could rest at a lunch counter on red vinyl stools and order a gooey grilled cheese or chicken salad sandwich, a fresh orangeade, a cherry Coke, a hot dog "all the way" or a steaming cup of coffee.

What more could any shopper want?

Purchasing 1924 Necessities

Ladies could purchase silk and woolen dresses at London's on North Main Street, High Point, for as little as $4.98. Coats cost from $10.95 to $25.00. Allen's Department Store advertised new fall hats for $5.95 and gloves or silk hosiery for $1.00 each. Belk Stevens Company sold ladies' hats "in leading shapes" for only $3.95. Women who sewed could buy dress ginghams for $0.10 per yard.

Women might be interested in a garment from Allen's Department Store: the Madame X Rubber Girdle, guaranteed to conceal big hips and make the wearer look twenty-five pounds slimmer. It "fits like a kid glove while it massages away the fat," one advertisement proclaimed. The more daring young lady might want to buy a pair of high-grade full-sized sateen bloomers for a mere forty-eight cents.

Suits for men, older and younger—in the newest colors—sold for "up to $25.00." At Moffits, a local store, gentlemen could buy silk hosiery for $1.00 a pair and silk neckties for $1.00 each.

For anyone suffering from "constipation, biliousness, torpid or sluggish liver, uric acid poisoning, and other ills, resulting from inactive liver and kidneys," LIV-0-KIDS were available at area drugstores for thirty-five cents and were, according to the High Point *Enterprise* advertising, "Worth It."

Shopping at the Cut Rate Grocery on Saturday, September 27, 1924, a homemaker could fill her grocery cart with picnic hams for $0.17 per pound, regular hams for $0.25 per pound and freshly ground coffee for $0.30 per pound. A small can of milk cost $0.05. Apples sold for $0.50 per peck. Irish

potatoes cost $0.35 per peck. One dollar would buy twenty-four pounds of flour. Holmes' Cash Grocery offered twenty-four pounds of Gold Medal Biscuit flour for $1.15.

Although these prices seem cheap to today's consumers, complaints did surface. Albert Apple wrote a column in the newspaper lamenting the exit of the five-cent cup of coffee, but he contended, "That's life," as he looked at the other five-cent buys that had ceased—a big piece of pie, the nickel cigar and the ice cream soda.

A wise consumer on a budget could always shop at Dixie Values, where felt hats cost $0.08 each, silk hoses $0.19 each, chambray full-cut work shirts $0.59 each, suspender-high back overalls $1.48 each, ribbed union suits (guaranteed to have a snug fit at wrist and ankle) $0.87 each, wool sweaters with rolled collars $1.67 each and "Fancy Black Satin Strip Shoes" $2.37 per pair.

As an extra bonus, shoppers could purchase "the best grade of granulated sugar with every dollar purchased" for four and a half cents per pound. This was the bargain hunter's dream come true.

Tobacco Markets: Business and Pleasure

Once a year, Piedmont Triad farmers made their annual pilgrimage to downtown Winston-Salem. The opening of the tobacco sales warehouses flooded the area with prospective buyers and sellers. Farmers used circular baskets to haul their hands (a "hand" equaled the number of leaves the farmer could hold in one hand while another man tied or knotted the ends of the stem with another leaf) of tobacco to various warehouses.

Workers weighed the hands of bright leaf tobacco, inspected and graded them and then auctioned them to the highest bidder. The chant of an auctioneer, the pungent aroma of cured tobacco and the eagerness of farmers to secure a good price lent an air of festivity to the scene—definitely a male-dominated event where women did not belong.

If the tobacco farmer did not accept a particular bid for his product, he would "turn the ticket" or refuse the bid, pack up his tobacco, hoist his leaves onto his hip and leave the warehouse. He waited until the next day, when prices might be better. When he felt he had received the price that compensated for his and his wife's backbreaking days in the fields, the farmer sold his crop, went to the payoff office and collected the money that would feed and clothe his family for the next year.

The pleasure associated with the tobacco markets came after the warehouses closed for the day. Out on the street, merchants sold everything

Taking tobacco to market. *Library of Congress.*

Tobacco field. *Library of Congress.*

from shoes, overalls and dress suits to fresh produce in open-air markets. Under signs that advertised "Drink Royal Crown Cola," farmers pressed against one another as they purchased goods that they wanted or needed.

Occasionally, they stopped for a shoeshine on Trade Street, listened to barkers hawking their wares or watched an Indian war dance. Buying and selling continued late into the night, and if farmers became bored with merchants, they could view some of the world's wonders, such as the smallest mule or figures from a portable wax museum. When they tired, they prepared a late supper by the light of lanterns and then slept in their covered wagons.

The next day these farmers were back in the warehouses, hoping for premium prices for their tobacco.

Halloween

Most people know some of the historical facts concerning Halloween, a holiday that dates back more than two thousand years and began with the Celtic people who lived in what is now Great Britain and northern France. The Celts, who worshipped nature, believed that on October 31 Samhain (pronounced *sow-in*), lord of the dead, would wander the entire earth with all of the dead souls.

To celebrate this event, the Celts donned costumes, wore animal heads and skins and told one another's fortunes. After the Romans conquered Celtic territory, by AD 43, two Roman festivals were added to the Celtic celebration of Samhain.

So what do these celebrations have to do with early elementary school Halloween festivals in the 1940s and 1950s? At Robins Elementary School in Lexington, the Halloween festival always began in the auditorium. Every seat was filled with costumed children and their parents. To kick off the festivities, schoolchildren were asked to gather at the back of the auditorium. While Mrs. Mary Crouse played the piano—usually a lively haunted tune—kids from grades one through six paraded down one aisle, up three steps, across the stage (decorated with jack-o'-lanterns, corn husks and scarecrows), down three steps on the other side and back up the opposite aisle from whence they started. Then, the procession repeated.

The majority of the costumes were homemade. Nurses, soldiers, cowboys, hobos, Indians, parlor maids, doctors and various and sundry animals paraded around and around—the piano still pounding scary tunes—until the judges had made their decision. "The winner is...."

Of course, amid all the home-sewn costumes, someone always had that professional, bought-from-an-upscale-catalogue look. And, sadly, this same girl wore the same costume through her entire elementary school career. She was the barefoot Carmen Miranda, the one with the store-bought pink and chartreuse sarong, purple halter and colorful artificial fruit piled to peak perfection on her head. She danced down that first aisle, across the stage and back down the second aisle—strutting her stuff. The cowboys and nurses knew immediately that they could take a hike; they didn't have a chance. After she was announced grand prize winner and given a box of candy, everyone applauded—like they meant it—and the initial Halloween opening ceremonies were over.

Next, everyone crowded out the side door of the auditorium, down the breezeway and into the classroom section of the old school. Each room held a different activity. In one first-grade classroom, a cakewalk was underway.

The fourth-grade room upstairs—dimly lit with flashlights—beckoned boys and girls to enter the Haunted House. Grapes for eyeballs, pork liver for innards and mushy oatmeal for intestines brought shrills of fright from everyone. A fishing booth delivered prizes after kids tossed poles over a makeshift curtain. Bobbing for apples was a popular game in yet another room. When all Halloween fun had been explored in various classrooms, kids crowded into the cafeteria for hot dogs, French fries and Cokes.

One columnist remembers spending Halloween evening at Robbins School:

> *Beloved Mrs. Owens of first grade fame appeared as an exotic Arabian fortune teller. "Your luckee color iss blue," she whispered with a hoarse accent. "Your luckee number, she iss seben and soon you weel meet a tall, dark and handsome stranger." Miss Thompson's second grade classroom was the highlight of the Robbins carnival, for it was converted into a true chamber of horrors. Eerie ghosts and witches (alias Miss Burgess and Miss Ledbetter, Mrs. Albright and Mrs. Curry) would lure us into its darkened interior, where we would be forced to feel corpse's eyeballs (grapes in Karo Syrup) and guts (cold spaghetti). We'd crawl through the tunnel of terror, brushing up against sewer rats and snakes, being screeched at by bats and owls and finally, being scared witless at the exit where a howling dangly skeleton would block our way.*

Last, and best of all, came the final hayride. A horse-drawn buggy, piled high with fresh straw, awaited outside at the basketball court, and dozens of screaming kids climbed aboard for the ride of their life up and down Main Street.

Halloween has never been more fun.

Creative Writing Contest

For its club year 1909–10, the North Carolina Federation of Women's Clubs sent out a call for what it called a "Paper Contest." The entries were divided into two groups, literary and historical. Judges selected one of each to be presented at the annual conference on "Fine Arts Evening." Of the thirteen papers submitted, judges chose "The Viking Age," by Mrs. W.L. Nicholson, and "The Development of the Drama," by Mrs. W.C.A. Hammel of the Friday Afternoon Club of Greensboro.

For the club year 1911–12, Miss Helen Montague of the Woman's Reading Club of Winston-Salem won first prize. As several years passed, more and

more entries were submitted, and by 1915, the committee had twenty-two submissions in poetry, nine in the short story and four in research.

Awarded Second Honor in 1915 was a piece entitled "A Singin' Lad" by Zoe Kincaid Brockman:

A Singin' Lad

He was a lad from an Irish town,
A blue-eyed lad with a smilin' brow,
An', brushin' aside the mists o' woe
That cling to my past, I can see him now,

His sweepin' lashes an' gold-flecked hair,
An' lips that curved in a wistful way,
So that his smile wrapped round your heart
Like the misty shine o' an April day.

An' the voice o' him when he'd sing a song,
The lilt o' his voice and the swing o' the tune,
It would carry you up, an' on, an' on,
Till you kissed the fairies that light the moon.

An' then he would sit an' brood an' brood
With the whole o' dreamland in his eye,
As tho' he could hear in his heart the rime
O' the clingin' shadows driftin' by.

Ah, but he was the lad to love,
But he thought o' it light, an' he went his way;
And he left an echo to break my heart,
Adrift in the shades o' the twilight grey.

The Old Rebel Pecos Pete Show

In the early days of TV—before cable and the dish—most households in the Piedmont Triad could get only two stations (and that was with rabbit ears). The most popular kids' show in the area was called *The Old Rebel Pecos Pete Show*. During the '60s and '70s, this program came on every Monday through Friday at 5:00 p.m. Children in the Piedmont flocked home from their outdoor

Six kids headed home to watch *The Old Rebel Show*.

afternoon play to see the show. They grew up with Old Rebel, Pecos Pete, Uncle Roy, Lonesome Lee, Coocoo the Clown and ventriloquist Ted Moss and his pal Hal. Kids looked forward to cartoons, including *Popeye*, *Wally Gator*, *Touche Turtle*, *Lippy the Lion* and *Space Angel*. Special themes, such as Indian Day, Cowboy Day and Favorite Toy Day, captured young viewers' attention.

Fifteen thousand youngsters joined the Old Rebel and Pecos Pete Club and became proud owners of a club song, code, pin and photograph album. They could burst forth with the show's theme song, which encouraged kids to behave responsibly, assist one another and take pride in all they did:

> *Some of us are rebels*
> *And some are buckaroos*
> *And we are very helpful*
> *From our helmets to our shoes*
> *And when we're asked to lend a hand*
> *We never do refuse*
> *'Cause some of us are rebels*
> *And some are buckaroos.*

George Perry played the Old Rebel, and Jim Tucker portrayed Pecos Pete from 1953 to 1965. These two stars also made many personal appearances at various benefits and parades. At the Greensboro National Theatre they had the pleasure of going backstage to meet the Carter Sisters. June Carter later married Johnny Cash. They also met Elvis Presley.

Today *The Old Rebel Pecos Pete Show* is off the air, but it continues to play in the hearts of those adults who religiously watched the show.

Woolworth's Greensboro Four Sit-Ins

Hidden tales accompany even the most famous Piedmont Triad history. Everyone knows about the four young men from North Carolina Agricultural and Technical College (A&T) who played a major role in integrating the Greensboro Woolworth's lunch counter in 1960. Few know about the downtown merchant who encouraged them and the African Americans first served at that famous counter.

A&T students Ezell Blair Jr., David Richmond, Franklin McCain and Joseph McNeil wondered why everybody walked away after they had been refused sit-down service at most establishments in the South. On February 1, 1960, these young African American men decided to take action. They met at the college library at 3:00 p.m. and walked to downtown Greensboro. They entered Ralph Johns's small clothing store and went directly to the back of the shop, where they reportedly told Mr. Johns that they were ready to act on the plans all of them had talked about previously.

Johns coached them on what they should do and say when they got to Woolworth's. He even had them practice in front of him before he gave them money to buy items when they got to the five-and-dime store. He also told them to be sure to get receipts for everything they bought.

Johns promised that he would pay any legal fees and bail them out of jail if the police arrested them. And there was one more thing: they should never let anyone know that he had anything to do with helping them. He also did not want to be called by his real name but rather wanted to be referred to as "Number 1." McNeil would become "Number 2"; Blair, "Number 3"; McCain, "Number 4"; and Richmond, "Number 5."

Why did Ralph Jones get involved with the four students and their mission? Perhaps he simply wanted to get more African American business for his clothing store. Maybe Johns had big dreams of becoming famous, and this was how he chose to do that. Or could he have been courageous enough to fight segregation? Maybe his motive was a combination of the three.

One fact is certain. After the four young men left Ralph Johns's clothing store, they turned onto South Elm Street at Jefferson Square. They stopped suddenly when they saw the red Woolworth's sign with gold lettering looming ahead. After talking about what might happen if they proceeded, they agreed to continue walking. They then went inside Woolworth's, but they split up in pairs and went to different counters in the store. They bought small items such as toothpaste, combs, pencils, notebooks and erasers. These purchases proved that blacks could be served anywhere in the store—except at the all-white sit-down lunch counter.

The young men took seats at the counter, but waitresses refused them service. The manager announced that the store would be closing early, so the boys filed out quietly through a side entrance. They, and many others, joined in the sit-ins for the next six days until all those involved called a two-week recess in protests. The Greensboro Four—as they are now called—returned to their studies after rejecting segregation by obstructing the wheels of injustice.

Ironically, these same men would not have the honor of eating the first meal at the newly integrated lunch counter. On July 25, 1960, Geneva Tisdale and two other female Woolworth kitchen workers, all wearing their best clothes, became the first African Americans served at the store's sit-down lunch counter. Tisdale had an egg salad sandwich and soda.

"It was a good sandwich," Tisdale told the press. "I know because I made it myself!" Years later, she was heard to say, "They never knew that it was Woolworth girls that was the first to sit at the counter to be served after they opened it up."

It was all over. The next day the *Daily News* printed a one-page column with no pictures. After that, news of the sit-ins became scarce.

Long-Ago Wedding on a Strict Budget

Many people enjoy reading the celebration sections of the Sunday newspapers. Weddings fascinate; they always have. Some don't attend many weddings these days, mainly because their friends and friends' children have already had their ceremonies (and, yes, the plural of "ceremony" adequately describes some of these unions). However magical, eclectic, lavish or exquisite our contemporary occasions, many can look back at the simplicity of weddings fifty or more years ago and marvel at the modest cost. Also interesting are the exquisite newspaper accounts of prenuptial parties and the ceremony itself. These detailed write-ups make what we would today call a "bare-bone-expense occasion" sound like one fit for royalty. Maybe all of this glorious accounting actually made up for the simplicity. Or perhaps acted as a mere cover-up?

The word "simplicity" might be an understatement. One couple had a 4:30 p.m. Sunday service in 1958. No reception followed; they greeted guests in the narthex of the church. The bride did not buy her dress or veil at a bridal shop; two women who worked at a local piece goods shops designed and stitched both. For some reason, the gown was never professionally pressed—probably because a local dry cleaning establishment would have

charged a couple of dollars to steam the wrinkles from the fabric. So, the bride wore a hoop skirt underneath to make the satin appear smoother. The crinkles and folds remained, as evidenced by her wedding portrait, but somehow, in the picture, they look more like deliberate puckers or French shirring.

The local newspaper account describes the twenty-five-dollar bridal gown in this way:

> *The bride was attired in an exquisite gown of white bridal satin styled with a fitted bodice featuring a round neckline with appliqués of imported Chantilly lace and short, shirred sleeves. Lace and seed pearl appliqué fashioned the gown's full skirt. Its two lace panels, accentuated at the waistline with a bustle bow, ended in a cathedral train.*

Sounds impressive, doesn't it? No mention of the wrinkles.

Now, for an account of the bridal bouquet's uniqueness: "A complimenting note was her cascade bouquet, composed of real chicken and turkey wish bones which she had saved during the years, and arranged with valley lilies and stephanotis surrounding its white orchid center." When the florist balked mildly about having to wrap the dozen or so brittle, dried chicken bones in white satin and said she would have to charge twenty-five cents extra for each, the mother of the bride said they would wrap them themselves and bring them back for the florist to insert in the bouquet. This they did; however, their frugality concerning the bouquet did not appear in the nuptial announcement, only a detailed account of "baskets of white gladioli, chrysanthemums and snapdragons" surrounded by "seven branched candelabra illuminating the setting with banked palms forming the background."

The guest soloist, a talented family member, performed gratis as her wedding gift to the couple. This musical program is detailed in this fashion in the newspaper account: "Following organ selections including 'Liebestraum' by Listz; 'Poeme' by Fibach; 'Meditation' by Mendelssohn, 'Calm As the Night' by Boehm; and 'Romance' by Rubinstein, the bride's new sister-in-law sang 'O Perfect Love' and 'Serenade,' and 'Wedding Prayer' by Dunlap." Sounds like a recital in a majestic cathedral, doesn't it? Ironically, a few of the famous composers' names were misspelled in the newspaper announcement.

That's genuine hidden history when a marriage on a minimal budget can read like a fairy-princess-and-prince event.

Return to Mayberry

Mount Airy, North Carolina, is Andy Griffith's hometown. Mayberry, slow-paced and sleepy, was modeled on this real place for the long run (and now reruns) of *The Andy Griffith Show*. While this will not surprise many people in the Piedmont Triad, Thelma Lou's return to Mount Airy as a permanent resident may not be common knowledge for some.

Her real name is Betty Lynn, and she's in her early eighties now. A couple of years ago she decided to move 2,100 miles to Mount Airy, as close as she could get to her beloved fictional Mayberry. "There's *no* place like it, unless it's heaven," she declared over her lunch of hamburger and onions.

Of course, Lynn is best remembered as Thelma Lou, Deputy Barney Fife's steady gal. Although they always experienced both joy and misunderstanding, the viewing audience perceived them as the perfect match.

From 1961 to 1966, Lynn played the role of Thelma Lou for only twenty-five or twenty-six episodes. Reports differ. Like all other characters on *The Andy Griffith Show*, Lynn is still adored by club members and nostalgia buffs. Consequently, she and the rest of the cast are the topic of college courses and Sunday school lessons.

When Deputy Barney Fife decided to move and join the Raleigh police force, his and Thelma Lou's relationship was put on hold. Barney returned to Mayberry in a season-six episode to attend his high school reunion. He then learned that Thelma Lou had married someone else. A happy ending, though, did come later, when Barney and the now widowed Thelma Lou got back together and were married in 1966's *Return to Mayberry* movie.

First Guilford County Court

The first Guilford county seat was at the home of Robert Lindsay on Deep River from 1771 to 1774. According to one regional historian, the house made of white clapboard had blue-green wooden shutters. Stone steps led to the three front doors, called witches doors. Some believe that John Lindsay, Robert's father, originally built a log house on the plantation but later erected the central portion of the manor house. Robert, upon inheriting the property, added two wings for his family residence, the court and a tavern.

The Great Hall in the central portion of the house became the place where Guilford County Court was held.

A barn and slaves' quarters and their burying grounds stood to the northwest of the house. Many servants living on the property planted

Standing remains of the house in which the first Guilford County court was held.

and harvested the crops. They also tended the mulberry trees that raised silkworms and fruit trees brought from the coast.

To the rear of the house a formal garden flourished. The Lindsay family burying ground, a quiet and beautiful spot, lay just beyond the garden. A tanyard (the section in a tannery where the tanning vats are located) and a silk mill loomed across the road. The gristmill stood about two thousand feet southeast of the house on the far bank of Deep River. In addition, a still was conveniently situated on Still House Creek, just short of a mile southwest of the house.

Robert Lindsay also operated a store on his two thousand acres. A road went to the store while a private drive, bordered by cedars, large English boxwoods and mulberry trees, led to the mansion house. The Lindsays had goods hauled by wagon from New York and Wilmington. He sold "Irish Linnings, Cambricks, Lawns, Silks, and Gauzes, Caligoes Chints, men and womens Worsted, Hoes, Syths, Hats, Books, & Many Other Articles."

On August 8, 1769, Robert was granted a license to keep a tavern at his dwelling. The men who came to grind their grain, purchase items from the store or tend to court business lodged overnight in the tavern. By 1741, the colonial assembly had required that all public housekeepers apply for and take out a license. The penalty for not doing this earned the perpetrator thirty lashes at the public whipping post (first offense) or, for subsequent offenses, thirty-nine lashes and a month in prison or a fine amounting to five to ten pounds. The license cost between two and four pounds, plus thirty pounds bond money.

Taverns traditionally were a step up from ordinaries (usually one-room log cabins, sparsely furnished and often inhabited by insects and snoring men). Taverns generally provided better food and more spacious lodging quarters with closets. Travelers enjoyed games of billiards, hazard, all-fours, backgammon, chess, draughts, whist, piquet and quadrille.

Sending Colorful Postcards

Although our days of sending any kind of personal correspondence through the mail have all but ceased, Piedmont Triad folks went through a period of time when they enjoyed sending picture postcards with every subject imaginable.

According to one source, "[d]eltiology, the official name for postcard collecting, is thought to be one of the three largest collectable hobbies in

This page: Years ago people enjoyed receiving and sending cartoon postcards. *Author's private antique postcard collection.*

This page: The whimsical and inimitable postcards of yesteryear. *Author's private antique postcard collection.*

A cartoon postcard like the ones often sent years ago. *Author's private antique postcard collection.*

the world along with coin and stamp collecting." During World War II, postcards showed military cartoons. One such picture shows a soldier with his commanding officer. The recruit has obviously brought seven suitcases and a set of golf clubs when he arrived for active duty. The caption reads: "Sure I can get all my bags in, Sarge, but where am **I** gonna sleep?"

Other popular styles after the war offered lighthearted garbs and comic topics, such as "P.S. I'm the One in the Middle," "Idiot Award," "Permit to be a Pig" and "Permit Not to Do Homework." Some cards offered other messages, such as "Don't Marry an Automobile Wife on a Wheelbarrow Salary" and "Nobody Loves a Gal with Fat Legs—Only the Mosquitoes."

Humorous postcards depicted cartoon drawings, often with puns and "Did This Ever Happen to You" captions. On the serious side, many romantic scenes featured courtship pictures, often with a flair for dramatic interludes, such as couples dancing on the beach, in the middle of waterfalls and in Victorian-like room settings.

Then, there are the bawdy pictures—with captions to match. Many of these might be considered naughty, with what might be called "pin-up girl" cartoon pictures and salty captions.

In addition to the whimsical subject matter, history was often revealed on postcards—from events to buildings, art and famous people.

High Point Home Furniture Market

Speak of the High Point Home Furniture Market, and Piedmont Triad natives know the story—at least most of it. They'll tell you about the largest furnishings industry trade show in the world. They know about the two major shows each year, one in April and another in October. They also know of the approximately eighty-five thousand people who come to High Point every six months, the shuttle service and online registration.

Most Piedmont Triad folks, however, would be surprised to learn that the first formal Southern Furniture Market of High Point, North Carolina, was held in March 1909. Actually, furniture manufacturing began as early as 1889, when the High Point Furniture Manufacturing Company shipped its first piece, an office desk, in July of that year.

By June 1921, the Exposition Building, costing about $1 million, opened for its first show in 249,000 square feet of space. Twenty years later, in 1941, after Japan attacked Pearl Harbor and the United States entered World War II, furniture making focused on the war effort, so except for 1943, there were no other markets held until the war ended.

To celebrate its claim to furniture fame, High Point, declared the "Home Furnishings Capital of the World," boasts two giant chests of drawers. Built

Old High Point railroad station.

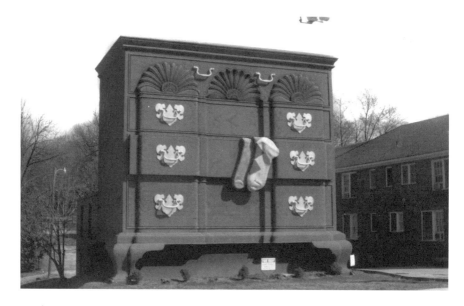

The High Point cedar chest with socks.

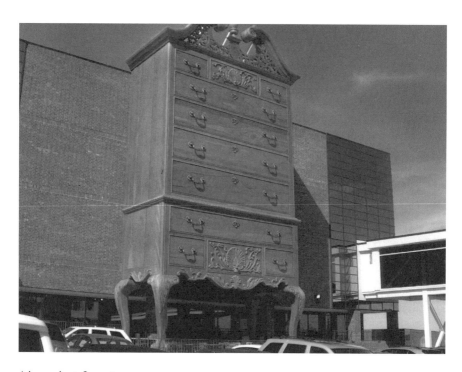

A large chest, Jamestown.

in the 1920s, the first piece was renovated in 1996 when it became a thirty-eight-foot Goddard-Townsend block front chest. Dangling from a drawer are two huge socks, symbolizing High Point's hosiery industry.

The second chest of drawers, over eighty feet tall, is attached to a big furniture store. Although not freestanding, this enormous structure also provides sightseers a reason to grab their cameras.

Catastrophe in Winston-Salem

In November 1917, Jim and Cora Childress, a white couple, started walking to a country store in Winston. When they had gone only a little way, a man came out of nowhere and pointed a gun in their faces. He then shot Mr. Childress and raped his wife in one of the gullies that ran by the railroad tracks.

The accused attacker was a black man named Russell High, who had recently moved to Winston from Durham. Mrs. Childress said that High wasn't the man responsible for hurting her and her husband, but by that time feelings were running strong. High was taken to jail. Even though officials had possibly arrested the wrong man, white men immediately started swarming city hall, where High was incarcerated. They wanted a lynching, and their emotions heated up outside the Winston-Salem jail. By early evening, the irate mob had rushed Russell High's cellblock and fired random gunshots. Firemen, called to the scene, hosed the crowd. In the confusion, a stray bullet wounded former fireman Robert Young. After the force of water coming from the fire hoses repelled the mob, the angered men fled, only to break into downtown stores and steal guns. Now armed, they tore into African American neighborhoods, shooting aimlessly, wounding many and killing twenty-three people.

Federal troops came in and brought a tank to the town square. Soldiers walked the streets for a while and then took Russell High to the jail in Raleigh, but not before many Winston-Salem African Americans were killed. Reports indicated that the dead were hauled out of Winston-Salem in boxcars and shipped out of town. Others were dumped in big holes.

The fate of Russell High remains a mystery—another part of the Piedmont Triad's hidden history.

BIBLIOGRAPHY

Adams, Louise. Personal interview. Summer 1987.

Alfano, Sean. "Bravery in the Face of Bigotry." CBS News. www.cbsnews. com/stories/2006/04/07.

"The Andy Griffith Show: The Real Thelma Lou's Return to Mayberry." IMDb. June 2, 2008. http://www.imdb.com/news/ni0597226.

"The Andy Griffith Show." Wikipedia, the free encyclopedia. www. en.wikipedia.org/wiki/The_Andy_Griffith_Show.

Arnett, Ethel Stephens. *Greensboro, North Carolina, the County Seat of Guilford*. Chapel Hill: University of North Carolina Press, 1955.

————. *Mrs. James Madison: The Incomparable Dolley*. Greensboro, NC: Piedmont Press, 1972. Chapel Hill: University of North Carolina Press, 1955.

"Asheboro, North Carolina." Wikipedia, the free encyclopedia. www. en.wikipedia.org/wiki/Asheboro.

"Bennett College Profile." Top Black Colleges and Universities. http://www. blackcollegesearch.com/north-carolina-colleges/bennett-college.htm.

"Bethabara Park Fieldschool." Archaeology Department. Wake Forest University. http://www.wfu.edu/anthropology/archeology/fs/bethabara. html.

"Bethania, North Carolina." Wikipedia, the free encyclopedia. www. en.wikipedia.org/wiki/Bethania.

"Betty Feezor TV Brownie Recipe—An Old but Good One." http:// cooking.consumerhelpweb.com/sinfultreats/bettyfeezorbrownies.htm.

Blakeney, Mary Lou Andrews. "Feb. 11, 1960: Sit-ins Come to High Pont." *News & Record*, February 1, 2009, section H, 1.

"Blandwood: History of the Mansion." History of Preservation Greensboro Incorporated. http://www.blandwood.org/history.html.

Bowles, Elisabeth Ann. *A Good Beginning: The First Four Decades of the University of North Carolina at Greensboro*. Chapel Hill: University of North Carolina Press, 1967.

"A Brief History of Haw River, North Carolina." Haw River Historical Association. http://www.rootsweb.ancestry.com/~nchrha/History.htm.

Brooks, Aubrey Lee. "David Caldwell and His Log College." *N.C. Historical Review* 28 (October 1951): 399–407.

Burns-Vann, Tracey, and Andre D. Vann. *Sedalia and the Palmer Memorial Institute*. Charleston, SC: Arcadia Publishing, 2004.

"Captain Peter Summers." http://freepages.genealogy.rootsweb.ancestry. com/~bruckner/captpeter.htm.

Charlotte Hawkins Brown. The State Library of North Carolina. http:// statelibrary.ncdcr.gov/nc/bio/afro/BROWN.HTM.

"Charlotte Hawkins Greensboro North Carolina: Who Was Charlotte Hawkins Brown?" http://www.ohenryhotel.com/charlotte_hawkins_ brown.htm.

"Chinqua Penn Plantation." Wikipedia, the free encyclopedia. http:// en.wikipedia.org/wiki/Chinqua_Penn_Plantation.

Coble, Herman. Personal interview. July 13, 1987.

Coffin, Levi. *Reminiscences of Levi Coffin, the Reputed President of the Underground Railroad*. Cincinnati, OH: Western Tract Society, 1876.

"Columbia Law: Portraits 11–22: Women at CLS." Columbia Law School. http://www.law.columbia.edu/law_school/communications/reports/ Fall2002/portraits11_22.

Cone Mill Corp. *A Century of Excellence: The History of Cone Mills, 1891 to 1991*. Edited by Carolyn R. Hines. Greensboro, NC: Cone Mills Corp., 1991.

Cramer, Mrs. John T. "Early History of Thomasville by Granddaughter of Founder." *Chairtown News*, July 28, 1921.

"David Caldwell." The Restoration Movement. www. therestorationmovement.com/caldwell,david.htm.

Dispatch. "Roman Charged." August 16, 1951.

———. "Woman Brutally Murdered." August 13, 1951.

"Eden, NC History." Eden Chamber of Commerce—Eden, North Carolina (NC). www.edenchamber.com/history.html.

Edmunds, Mary Lewis Rucker. *Governor Morehead's Blandwood and the Family Who Lived There*. Greensboro, NC: Greensboro Printing, 1976.

"Eileen Fulton Biography." Eileen Fulton. www.eileenfulton.com/biography. htm.

"Elreta Melton Alexandaer." http://myweb.wvnet.edu/~jelkins/lp-2001/ alexander_elreta.html.

"Encyclopedia>Dolley Madison." http://www.nationmaster.com/ encyclopedia/Dolley-Madison.

Essex (automobile). Wikipedia, the free encyclopedia. http://en.wikipedia.org/wiki/Essex_(automobile).

Frady, Marshall. *Jesse: The Life and Pilgrimage of Jesse Jackson*. New York: Simon & Schuster, 2006.

Gilbert, Dorothy Lloyd. *Guilford: A Quaker College*. Greensboro, NC: Joseph J. Stone, 1937.

Greensboro College. *Recollections and Other Facts Connected with Greensboro College*. Greensboro, NC: Piedmont Press, 1946.

"Greensboro's Treasured Places: Future-Perfect-in-Past-Tense: Reclaiming the Historic Warnersville Neighborhood." Preservation Greensboro. http://preservationgreensboro.typepad.com/weblog/2008/04/future-perfect.html.

Hairston, Peter. *The Cooleemee Plantation and Its People*. Winston-Salem, NC: Hunter Publishing Company, 1986. Copies are available at the Davidson Community College Business Office, Lexington, North Carolina.

Harrington, Kady. "Lydia's Bridge or The Ghostly Hitchhiker." Haunted North Carolina Paranormal Research & Investigations. http://www.hauntednc.com/legends_lydiasbridge.htm.

"Haunted Places in North Carolina." Shadowlands Haunted Places Index—North Carolina. www.theshadowlands.net/places/northcarolina.htm.

Haynes, Page S. "An Era of Only Ghosts and Tramps." *Dispatch*. Date unknown.

High Point Enterprise. Advertisements from September 16, 26, 3, 17, 1914, and October 3, 1924.

"High Point Market." Wikipedia, the free encyclopedia. http://en.wikipedia.org/wiki/High_Point_Market.

"Historic Bethabara Park." City of Winston-Salem, North Carolina. http://www.cityofws.org/Home/Departments/RecreationAndParks/BethabaraPark/Articles/BethabaraPark.

"Historic Bethabara Park." http://www.volunteermatch.org/search/org76615.jsp.

"History: 1925–1965." Chinqua Penn Plantation. http://www.chinquapenn.com/history.html.

"The History of Proximity Cotton Mill and Proximity Print Works." Proximity Hotel, Greensboro, North Carolina. http://www.proximityhotel.com/history.htm.

"The History of the Automobile." The Impact of the Automobile on the 20th Century. The Center for Lifelong Learning and Design. http://l3d.cs.colorado.edu/systems/agentsheets/New-Vista/automobile/history.html.

"The History of UNCG." University of North Carolina Greensboro. http://www.uncg.edu/campus_links/inside_uncg/inside_history.html.

"History: Town of Jamestown: Walking with History." http://www.jamestown-nc.us/history.html.

"Introduction to Guilford College." Guilford College. www.guilford.edu/academics/catalog/intro.html.

"John Coltrane." Wikipedia, the free encyclopedia. www.en.wikipedia.org/wiki/John_Contrane.

"John William Coltrane." http://www.findagrave.com/cgi-bin/fg.cgi?page=gr&GRid=218.

Jones, M. Bruce, and Trudy J. Smith. *White Christmas, Bloody Christmas*. Trinity, NC: UpWords Publications. 1990.

Knapp, Richard F., and Brent D. Glass. *Gold Mining in North Carolina: A Bicentennial History*. Greenville: North Carolina Division of Archives & History, 1999.

Lancaster, Brent. "Preddy Fighter Ace Legends Live on Through Cousin." *Greensboro Telegram*, December 25, 2008.

Leonard, Jeanne. "Where Oh Where Have the Dime Stores in Downtown Gone?" *Dispatch*, December 11, 2008.

Lewis, Cynthia. "Monstrous Arrogance: Husbands Who Choose Murder over Divorce." *Journal of Criminal Justice and Popular Culture* 15, no. 1 (2008).

Libby, Bill, with Richard Petty. *King Richard: The Richard Petty Story*. New York: Doubleday & Company, Inc., 1977.

"Libby Holman—Biography." Internet Movie Database. www.imdb.com/name/nm2071916/bio.

Linn, Jo White. *Diary of Elizabeth Dick Lindsay: February 1, 1837–May 3, 1861*. Salisbury, NC: Salisbury Printing Co., 1975.

Locke, William R. *No Easy Task: The First Fifty Years of High Point College*. Greensboro, NC: Piedmont Press, 1974.

Machlin, Milt. *Libby*. New York: Tower, 1980.

"Main Entrance Greensboro, NC." http://www.cardcow.com/13021/main-entrance-greensboro-us-state-town-views-north-carolina-greensboro.

Marshall, Mike. E-mail interview about Mamie Guyer.

Marteena, Constance Hill. *The Lengthening Shadow of a Woman: A Biography of Charlotte Hawkins Brown*. [Hicksville, OH?]: Exposition, 1977.

Martin, Connie. Personal interview with director of Korner's Folly. February 7, 2009.

"Michael Hayes." Wikipedia, the free encyclopedia. http://en.wikipedia.org/wiki/Michael_Hayes_(spree_killer).

"More on Wagon." Back of "Our Wagon." Mendenhall Plantation. http://www.mendenhallplantation.org/More%20on%20Wagon.htm.

News & Record. "Monument to Youths." February 15, 2009.

"Newsletter of the Society for the History of Children and Youth. Part 3: Josephine Boyd of Greensboro, North Carolina." https://www.h-net.org/~child/newsletters/newsletter4/Wallenstein3.html.

"North Carolina Agricultural and Technical State University." Wikipedia, the free encyclopedia. http://en.wikipedia.org/wiki/North_Carolina_Agricultural_and_Technical_State_University.

North Carolina Department of Cultural Resources. "Lunsford Richardson." North Carolina Museum of History Office of Archives and History. North Carolina Department of Cultural Resources. Raleigh, NC: 2005.

The North Carolina Federation of Women's Clubs. *Stories and Poems from the Old North State.* Durham, NC: Seeman Printery Incorporated, 1923.

"North Carolina Ghosts and Legends." http://www.northcarolinaghosts.com.

"O. Henry." Wikipedia, the free encyclopedia. www.en.wikipedia.org/wiki/O.Henry.

"The Old Rebel Show—the 50s & 60s." www.tvparty.com/oldrebel/50.html.

Olsen, Otto H. *Carpetbagger's Crusade: The Life of Albion Winegar Tourgee.* Baltimore, MD: Johns Hopkins University Press, 1965.

"Peter Doub: A Man of Great Faith." Online excerpt from Ms. Margaret Ann Hites's 1969 thesis entitled "Peter Doub, 1796–1869: His contribution to the religious and educational development of North Carolina." http://museum.greensborocollege.edu/Peter_Doub.htm.

Phipps, Nikki. "Haunted Places In and Around King, NC." http://www.associatedcontent.com/article/622387/haunted_places_in_and_around_king_nc.html?cat=16.

Rowe, Jeri. "Pilot's Portrait Rolls Back Years." *News & Record,* December 18, 2008, Section B, 1–2.

———. "Warnersville Residents Hope 5 Benches Will Lead the Way." *News & Record,* March 8, 2009.

"Salem College." Wikipedia, the free encyclopedia. www.wilipedia.org/wiki/Salem_College.

Schlosser, Jim. "Museum to Tell the Story of Greensboro in a New Way." *News & Record,* November 3, 2008.

Schutze, Jim. *Preacher's Girl: The Life and Crimes of Blanche Taylor Moore.* New York: William Morrow & Co., Inc., 1993.

Shapiro, Phil. "My Old Hardware Store." www.his.com/pshapiro/hardware. store.html.

Sieg, Tom, and Greg Hitt. "The Victims: One by One, a Happy Sunday Came to a Bitter End for Four." *Winston-Salem Journal* (July 19, 1988).

Silcox-Jarrett, Diane. *Charlotte Hawkins Brown, One Woman's Dream*. Winston-Salem, NC: Bandit, 1995.

Sink, Alice E. "Battle of Guilford Courthouse." Unpublished article.

Sink, Alice E., and Nickie Doyal. *Boarding House Reach: North Carolina's Entrepreneurial Women*. Wilmington, NC: Dram Tree Books, 2007.

———. *The Grit Behind the Miracle*. Lanham, MD: University Press of American, Inc., 1998.

———. "Katharine Smith Reynolds: A Story of Her Life". Unpublished manuscript.

Sink, M. Jewell, and Mary Green Matthews. *Pathfinders Past and Present: A History of Davidson County, North Carolina*. North Carolina: Hall Printing Company, 1972.

Smith, C. Alphonso. *O Henry Biography*. Garden City, NY: Doubleday, Page and Co., 1916.

Smith, Trudy J. *The Meaning of Our Tears*. Asheboro, NC: DTS Group, Inc., 2006.

Stevenson, J.S. "Everybody's Hospital: A Brief History of the Central Carolina Convalescent Hospital." Abstract PMID: 5216725, 1966.

"Tanglewood Park—Park Information—Park History." http://www. co.forsyth.nc.us/Tanglewood/park_History.aspx.

"Thomasville, North Carolina." Wikipedia, the free encyclopedia. www. en.wikipedia.org/wiki/Thomasville.

Times-News. "Saxapahaw." Living Here Section. August 31, 2008.

Turrentine, Samuel Bryant. *A Romance of Education: A Narrative Including Recollections and Other Facts Connected with Greensboro College*. Greensboro, NC: Piedmont Press, 1946.

United Methodist Congregation. "A Place for Shalom: Case Statement for Green Street Church." Winston-Salem, NC: United Methodist Congregation, 2007.

Wiencek, Henry. *The Hairstons: An American Family in Black and White*. New York: St. Martin's Griffin, 2000.

"William Blum Thalhimer, Jr.: Corporate and family archives, 1862–1992." Virginia Historical Society: Manuscripts and Archives Finding Aids. http://www.vahistorical.org/arvfind/thalhimer.htm.

Wireback, Taft. "Money to Open Museum Could be in Hand Soon." *News & Record,*. January 9, 2009.

———. "We All Went for the Seats." *News & Record*, February 8, 2009.

Wolff, Miles. *Lunch at the Five and Ten.* New York: Stein and Day, 1970.

"World's Largest Chest of Drawers. High Point, North Carolina." http://www.roadsideamerica.com/story/2148.

"The writings of George Washington from the original manuscript sources." Electronic Text Center, University of Virginia Library. http://etext.virginia.edu/toc/modeng/public/WasFi39.html.

"Wright Tavern—Rockingham County, North Carolina." http://www.rockinghamcountyhistory.com/id23.htm.

Yarborough, Ellen S. Personal interview. Tuesday, January 27, 2009.

Yarborough, N.P. Personal interview. Summer 1987.

ABOUT THE AUTHOR

Alice E. Sink is the published author of books and numerous short stories, articles and essays in anthologies and in trade and literary magazines. She earned her MFA in creative writing from the University of North Carolina Greensboro. For twenty-eight years she has taught writing courses at High Point University in High Point, North Carolina, where she received the Meredith Clark Slane Distinguished Teaching/Service Award in 2002. The North Carolina Arts Council and the partnering arts councils of the Central Piedmont Regional Artists Hub Program awarded Sink a 2007 grant to promote her writing.

If you enjoyed this book, you may also enjoy
Michael L. Marshall & Jerry L. Taylor's

Wicked Kernersville

$19.99 • 128 pages • 15 illustrations • ISBN 978-1-59629-676-3

The central Piedmont North Carolina town of Kernersville is known today for its quiet neighborhoods and lovely historic district homes. Few of its citizens would suspect that in earlier times the town had its fair share of unsavory characters. *Wicked Kernersville* lifts the veil from this little-known facet of the town's past and introduces the reader to incidents that prompted one early resident to lament that it was unsafe to walk the streets. Using material gleaned from old newspapers and other sources, Kernersville natives Michael L. Marshall and Jerry L. Taylor bring these stories to life, giving the reader a glimpse of the town's history unavailable from other sources.